Dialogues on the Supersensual Life

Jakob Bohme

Dialogues on the Supersensual Life

The present edition is a reproduction of previous publication of this classic work. Minor typographical errors may have been corrected without note; however, for an authentic reading experience the spelling, punctuation, and capitalization have been retained from the original text.

ISBN: 979-8-88830-417-4

CONTENTS

OF THE SUPERSENSUAL LIFE
IN DIALOGUES
BETWEEN A SCHOLAR OR DISCIPLE AND HIS MASTER

PREFACE

The Works of Jacob Behmen, the "Teutonic Theosopher," translated into English, were first printed in England in the seventeenth century, between 1644 and 1662. In the following century a complete edition in four large volumes was produced by some of the disciples of William Law. This edition, completed in the year 1781, was compiled in part from the older English edition, and in part from later fragmentary translations by Law and others. It is not easily accessible to the general reader, and, moreover, the greater part of Behmen's Works could not be recommended save to those who had the time and power to plunge into that deep sea in search of the many noble pearls which it contains.

Behmen's language and way of thought are remote and strange, and in reading his thought one has often to pass it through a process of intellectual translation. This is chiefly true of his earlier work, the "Aurora" or "Morning Redness." But among those works which he wrote during the last five years of his life there are some written in a thought-language less difficult to be understood, yet containing the essential teaching of this humble Master of Divine Science. From these I have selected some which may, in a small volume, be useful. It seemed that for this purpose it would be best to take the "Dialogues of the Supersensual Life," including as one of them the beautiful, really separate, Dialogue, called in the Complete Works, "The way from darkness to true illumination." In the case of neither of these works is the translation used that of the seventeenth century. The first three dialogues are a translation made by William Law, one of the greatest masters of the English language, and found in MS. after his death. This translation from the original German is

not exactly literal, but rather a liberal version, or paraphrase, the thought of Behmen being expanded and elucidated, though in nowise departed from. The dialogue called "The way from darkness to true illumination" was taken by the eighteenth century editors from a book containing translations of certain smaller treatises of Behmen then lately printed at Bristol and made, as they say, "in a style better adapted to the taste and more accommodated to the apprehension of modern readers." I do not know who was the translator, but the work seems to be excellently well done.

It will be well to say a few words first as to the life, then as to the leading ideas of Jacob Behmen. This name is more correctly written Jacob Bœhme, but I prefer to retain the more easily pronounced spelling of Behmen, adopted by the Editors of both the complete English editions.

Jacob Behmen's outward life was simplicity itself. He was born in the year 1575 at Alt Seidenberg, a village among pastoral hills, near Görlitz in Lusatia, a son of poor peasants. As a boy he watched the herds in the fields, and was then apprenticed to a shoemaker, being not enough robust for rural work. One day, when the master and his wife were out, and he was alone in the house, a stranger entered the shop and asked for a pair of shoes. Jacob had no authority to conclude a bargain and asked a high price for the shoes in the hope that the stranger would not buy. But the man paid the price, and when he had gone out into the street, called out "Jacob, come forth." Jacob obeyed the call, and now the stranger looked at him with a kindly, earnest, deep, soul-piercing gaze, and said, "Jacob, thou art as yet but little, but the time will come when thou shalt be great, and become another man, and the world shall marvel at thee. Therefore be pious, fear God, and reverence his Word; especially

read diligently the Holy Scriptures, where thou hast comfort and instruction; for thou must endure much misery and poverty, and suffer persecution. But be courageous and persevere, for God loves, and is gracious unto thee." So saying, the stranger clasped his hand, and disappeared.

After this Jacob became even more pensive and serious, and would admonish the other journeymen on the work-bench when they spoke lightly of sacred things. His master disliked this and dismissed him, saying that he would have no "house-prophet" to bring trouble into his house. Thus Jacob was forced to go forth into the world as a travelling journeyman, and, as he wandered about in that time of fierce religious discord, the world appeared to him to be a "Babel." He was himself afflicted by troubles and doubts, but clave to prayer and to Scripture, and especially to the words in Luke xi.; "How much more shall your heavenly Father give the Holy Spirit to them that ask him." And once, when he was again engaged for a time by a master, he was lifted into a state of blessed peace, a Sabbath of the Soul, that lasted for seven days, during which he was, as it were, inwardly surrounded by a Divine Light. "The triumph that was then in my soul I can neither tell nor describe. I can only liken it to a resurrection from the dead."

Jacob returned in 1594 to Görlitz, became a master shoemaker in 1599, married a tradesman's daughter, and had four children. In the year 1600 "sitting one day in his room, his eye fell upon a burnished pewter dish which reflected the sunshine with such marvellous splendour that he fell into a deep inward ecstasy and it seemed to him as if he could now look into the principles and deepest foundations of things. He believed that it was only a fancy, and in order to banish it from his mind he went out upon the green. But

here he remarked that he gazed into the very heart of things; the very herbs and grass, and that Nature harmonised with what he had inwardly seen. He said nothing about this to any one, but praised and thanked God in silence. He continued in the honest practice of his craft, was attentive to his domestic affairs, and was on terms of goodwill with all men." [1]

At the age of thirty-five, in the year 1610, Jacob Behmen suddenly perceived that all which he had seen in a fragmentary way was forming itself into a coherent whole, and felt a "fire-like" impulse, a yearning to write it down, as a "Memorial," not for publication, but lest he should forget it himself. He wrote it early in the morning before work, and late in the evening after work. This was his "Morning Redness" or "Aurora."

A nobleman of the country, called Carl von Endern, happened to see the MS. at the shoemaker's house, was struck by it, and had some copies made. One of these fell into the hands of the Lutheran Clergyman of Görlitz, Pastor Primarius Gregorius Richter, who thenceforth became a bitter opponent of Behmen. He assailed him in sermons, in language of savage invective, as a heretic of the most dangerous kind, until Jacob was summoned before the Magistrates, and forbidden to write anything in future. He was told that as a shoemaker he must confine himself to his own trade. But the affair, as is usually the case, had an effect the reverse of that intended by persecutors. It made him known to various persons more learned than himself who were interested in the subject, and from his converse with them he learned a better style, and some Latin

[1] From the Danish Bishop Martensen's book "Jacob Boehme"; an excellent study well translated from Danish into English by Mr T. Rhys Evans, (Hodder and Stoughton, London, 1885). An account of Behmen's life is given in the preface to the first volume of the last century English edition of the Works.

technical terms, which he afterwards found useful for expressing his thoughts.

Jacob obeyed for some years the magisterial command to write nothing, but it was very grievous to him, and he often reflected with dismay on the parable of the talents and how "that one talent which 'tis death to hide" was lodged with him useless. At length he would keep silence no more. He says himself: "I had resolved to do nothing in future, but to be quiet before God in obedience, and to let the devil, with all his host, sweep over me. But it was with me as when a seed is hidden in the earth. It grows up in storm and rough weather against all reason. For in winter time all is dead, and reason says: 'It is all over with it.' But the precious seed within me sprouted and grew green, oblivious of all storms, and, amid disgrace and ridicule, it has blossomed forth into a lily."

Between the year 1619 and his death in 1624, at the age of forty-nine, he poured forth his stored up thoughts, writing a number of Works, including those in the present volume, which were among his very latest. He had the more time to write because his shoemaking business had fallen off, by reason, perhaps, of the question as to his orthodoxy, but some friends supplied him with the necessaries of life. He was now exposed to fresh attacks from Gregorius Richter and was forced this time to go into exile. At this period he went to the Electoral Court at Dresden where the Prince was curious about him, and a conference took place between him and John Gerhard and other eminent theologians. At the close of this Dr Gerhard said: "I would not take the whole world and help to condemn this man." And his colleague Meissner said, "My good brother, neither would I. Who knows what stands behind this man? How can we judge what we have not understood? May God

5

convert this man if he is in error. He is a man of marvellously high mental gifts who at present can neither be condemned nor approved."

Soon afterwards, while Jacob was staying at the house of one of his noble friends in Silesia he fell into a fever. At his own request he was carried back to Görlitz, and there awaited his end. On Sunday, November 21st 1624, in the early hours he called his son Tobias and asked him if he did not hear that sweet melodious music. As Tobias heard nothing, Jacob asked him to set wide the door so that he might the better hear it; then he asked what was the hour, and when he was told that it had just struck two he said, "My time is not yet; three hours hence is my time." After some silence he exclaimed, "Oh thou strong God of Sabaoth, deliver me according to thy Will," and immediately afterwards "Thou Crucified Lord Jesus Christ have mercy upon me and take me to thyself into thy Kingdom." At six in the morning he suddenly bade them farewell with a smile, and said, "Now I go hence into Paradise," and yielded up his Spirit.

Frankenberg writes of him: "His bodily appearance was somewhat mean; he was small of stature, had a low forehead but prominent temples, a rather aquiline nose, a scanty beard, grey eyes, sparkling into heavenly blue, a feeble but genial voice. He was modest in his bearing, unassuming in conversation, lowly in conduct, patient in suffering, and gentle-hearted."

As the shoemaker of Görlitz had in his life-time some disciples among highly educated men, so has he always had a few since his departure from this life. Men so diversely situated as the non-juror William Law in England; St Martin, the "philosophe inconnu" of the French Revolution; the sincere Catholic, Franz Baader, in Germany;

Martensen, the Protestant Bishop in Denmark, have found in him their Teacher.

The selections contained in the present book belong rather to the practical or ethical side of Jacob Behmen's teaching than to his Cosmogony, or Vision, as one may best call it, of the nature of all things. I think that any old cottager, who had read nothing but his Bible, but had lived his life, would well understand the general teaching of most that is contained in these Dialogues, and would find all Behmen's words most beautiful and comforting. It is not, therefore, necessary for the present purpose to attempt fully to set forth the whole Vision of Behmen, nor, in any case would it be within my power to do so. But it may be of service to those readers who are not acquainted with the writings of Behmen or of his disciples, if I here say something as to his general teaching with regard to the nature of the soul of man and its relation to that which is not itself, but like to itself.

The Soul, in the doctrine of Behmen, is a Being which has a will or desire, and is aided by a mirror of understanding or imagination. Will or Desire is of the very essence of the Soul, inseparable from its existence. He says: "Where Desire is there is also Essence or Being." The Soul is subject to the diverse attractions of the Centre of Divine Life and Light, and of the Spirit of the World. Enlightened by its understanding it has the free power to turn its will towards, and unite itself to, this or that. "Choose well, thy choice is brief and yet endless."

The Soul is a magic Fire derived out of, or from, God the Father's Essence, lumen de lumine, and imprisoned in darkness. It is an intense and incessant Desire after the Light; it longs to return to the

Light-centre, whence it originally came, that is, to the "heart of God." Thus longing, it is a "Fire of Anguish," until it becomes a "Fire of Love." It is a fire of anguish, so long as it is shut up in its dark self. It is a fire of love when it pierces through and escapes from its dark self-prison and burns freely and softly in union with the Divine Love. God then comes as a Light, a soft purifying Fire into the Soul, and changes all the wanting, hungering, empty, restless, self-tormenting properties of the Natural Life into a sweetness of rest and peace. This is called in Scripture the "new birth." Thus the same thing—the same Fire,—is a cause of torment or of joy according to the conditions under which it is. Man, who is a microcosm of the whole Universe, is a mingling of light and darkness. His anguish comes from his Soul's imprisonment in darkness (as a mere raging fire) and continues until it can break forth and unite itself with that whence it came and to which it belongs.

Behmen says "The Eternal Darkness of the Soul is Hell, viz.: an aching source of anguish, which is called the Anger of God, but the Eternal Light in the Soul is the Kingdom of Heaven, where the fiery anguish of darkness is turned into joy. For the same nature of anguish, which, in the Darkness, is a cause of sadness, is, in the Light, a cause of the outward and stirring joy.... The Fire is painful and consuming, but the Light is yielding, friendly, powerful and delightful, a sweet and amiable Joy."

Pure delight, with no trace of doubt or fear, hope or regret, is the sign of the presence of Love or Light. So again Behmen says: "The Fire in the Light is a fire of Love, but the Fire in the Darkness is a fire of Anguish, and is painful, irksome, and full of contrariety." The end to which all things tend is the final separation of light from

8

darkness; the "last day" means this; but the present world is a perpetual mixture of light and darkness, good and evil, joy and anguish. So, the Cross of Jesus is at once the highest embodiment of Love and Hate.

It is remarkable that in this doctrine of light and darkness Behmen was nearly followed by one who had not, I suppose, ever heard of him, reading as he did little of anything but the Bible, who worked on the Scriptures with his own powerful and earnest insight, the Christian hero, Charles Gordon. In his little book called "Reflections in Palestine" written in that one year, 1883, of unbroken repose from action spent in the Holy Land, just before his final service at Khartoom, Gordon dwells upon the repetition, as he calls it, both in the individual soul, and in the world's history of four processes constantly recurring,—a state of darkness, a light breaking forth through darkness, a division of light from darkness or gathering together of light, a re-dispersion of light into darkness, and then a renewal of the four processes, ever upon an ascending level of good, directed towards the final elimination of all light from the darkness.

Fire must have fuel, something on which to feed. It must feed or perish. But the magic Fire-spirit, the Soul, cannot perish because it is an eternal Essence. Therefore it must either feed; or hunger. It desires spiritual essence or "virtue" to allay its raging hunger. But, during the space that it is embodied in this nature, it can feed either on the Divine Spirit, or upon the Spirit of this World. "Hence," says Behmen, "we may understand the cause of that infinite variety which is in the Wills and Actions of Men." For of whatsoever the Soul eateth, and wherewith its Fire-life becometh kindled; "according to that the Soul's life is led and governed." You become

9

like to that which you eat. If the Soul breaks forth out of its Nature-self and enters into "God's Love-fire," it eats of the Divine Essence (the substance or flesh of Christ) and it is to this that Jesus Christ referred when he spoke of feeding upon his body, and when he spoke of the true bread from heaven "which giveth life to the World" (John vi. 33), of which he that eateth shall "live for ever" (John vi. 58), or the "living water," whereof whosoever drinketh "shall never thirst," but it shall be to him "a well of water springing up into everlasting life" (John iv. 13, 14). This feeding is in no way metaphorical but as real and actual as physical feeding.

Behmen says, "The Essence of that Life eateth the Flesh of Christ and drinketh His Blood.... Now if the Soul eat of this sweet, holy and heavenly food, then it kindleth itself with the great Love in the name and power of Jesus, whence its fire of anguish becometh a great triumph of joy and glory." [2]

Behmen held that man lives at once in three worlds, firstly in the outward visible elementary world of space and time (where man "is the Time and in the Time;") secondly, the "Eternal Dark World, Hell, the centre of Eternal Nature, whence is generated the Soul-fire, that source of anguish, and thirdly, in the Eternal Light World,

[2] It should be noted that Jacob Behmen held strongly to the Sacrament of the Lord's Supper, the actual bread and wine as a "permissive medium" of the real feeding, in order that there may be "a visible sign of what is done in the inward ground." But he says "We should not depend on this means or medium alone, and think that Christ's Flesh and Blood is only and alone participated in this use of bread and wine, as Reason in this present time miserably erreth therein. No, that is not so. Faith, when it hungereth after God's love and grace, always eateth and drinketh of Christ's Flesh and Blood. Christ hath not bound himself to bread and wine alone, but hath bound himself to the faith, that he will be in men." Works, vol. iv. p. 208. Charles Gordon took the same view of the visible "eating," as being a great assistance to the spiritual feeding, but not indispensable to it. (Gordon's "Letters to his Sister.")

Heaven—the Divine habitation." The same processes of feeding and life take place in the three Worlds, so that physical feeding is a kind of outside sheath of spiritual feeding.

If the Soul accustoms itself to feed in this life upon the heavenly food (that panem de coelo omne delectamentum in se habentem) it gradually itself becomes of quite heavenly substance, purged from darkness, and, when the natural life falls off at death, stands in heaven, where indeed it already is. But, if the Soul feeds upon the Spirit and Things of this World, then, when by reason of death, it can no longer feed upon them, it is left in the condition of mere "aching Desire," or eternal unsatisfied Hunger, working in a void, in perpetual anguish. Thus Heaven and Hell are not places, but conditions of the Soul. So Milton, who had no doubt studied the translation of Behmen made in his own time, writes:

"The mind is its own place, and in itself
Can make a Heaven of Hell, a Hell of Heaven."

They are in this life everywhere commingled, but when this life falls away, the Soul remains in that of the two states into which it has in this life brought itself. The Soul, after death, remains either as a satisfied Desire, that is, a Desire no longer but a Joy, or as an aching Desire. The Persian says:—

Heaven is the vision of fulfilled Desire
And Hell the shadow of a Soul on fire.

Behmen says, Heaven is fulfilled desire; Hell is a Soul on fire, no mere vision or shadow.

Heaven and Hell are within us, since our souls are portions of the

universe of things, in every part of which Heaven and Hell are commingled. The gates of Heaven within us were shut in Adam, but the Power of God, Christ in Jesus, broke open by his passion "the closed gates of Paradise," that is, the gates of our "inward heavenly humanity," and now the wayfarer can, if he will, pass through. We do not spiritually live by a reasoning process, or acceptance of doctrines by the understanding, but by the action of the Desire in feeding upon the Spirit of Love, a process of laying hold, drawing in, and assimilating. True prayer is like feeding, or still more, perhaps, like the unconscious drawing in of the air: it should be as constant. By it is introduced the heavenly life from without to nourish the like heavenly life contained in the seed within. If a man thus rightly feeds, then, in him, the hellish life and passions, portions of the powers of darkness, "our creatures" as Behmen says, will be killed by starvation, wanting their appropriate food. On the other hand, a man can feed these also from without with their appropriate food by misdirected desire, thereby starving the heavenly life in the Soul.

Thus the essence of Behmen's teaching as to the Soul incarnate in Man and revealed by his body, is that it is an eternal Being, and that it is a source of joy or anguish according as it is, or is not, purified or tranquillised by communion with the Centre of Light, or the Fountain of Life. He does not contemplate, as some Eastern teachers perhaps do, the annihilation of the Will of the Soul by a kind of higher spiritual suicide; its existence is to him the very condition of good no less than of evil; he contemplates its liberation from the dark, contracted, self-prison, its purification, and entrance into the full heaven-life. This magical soul-fire, like visible fire, can rage and destroy, or it can serve as the means and ground of all good. Here is the foundation both of good and evil, in man as in all things.

To understand this better, one must consider the cosmic teaching lying behind the rich profusion of images, often inconsistent and clashing, in which Jacob Behmen embodies his Vision.

Man has fallen into Nature. But Nature itself, apart from and unfilled by the Divine Light, is a self-torment, a mere Want, a Desire, a Hunger. The true distinction between God and Nature is that God is an Universal All, while Nature is an Universal Want, viz: to be filled by God. Physical attraction is nothing but the outer sheath of this universal desire. Nature filled by God is Heaven or fulfilled Desire. [3] Without God it is Hell, mere Desire. Heaven is the Presence of God: Hell his Absence. It is as true to say that Heaven is in God, as to say that God is in Heaven.

Apart from the existence of God there could be neither Presence nor Absence, neither Heaven nor Hell. If the Soul of Man were wholly divided and separated from the Divine Life, it would, as a part of Nature, be a mere hungering, restless, conscious Desire. In so far as it is so separated it partakes of this pain. For "through all the Universe of Things nothing is uneasy, unsatisfied, or restless, but because it is not governed by Love, or because its Nature has not reached or attained the full birth of the Spirit of Love. For when that is done, every hunger is satisfied, and all complaining, murmuring, accusing, resenting, revenging and striving are as totally suppressed and overcome as coldness, thickness and horror of darkness are suppressed and overcome by the breaking forth of the light. If you ask why the Spirit of Love cannot be displeased, cannot be disappointed, cannot complain, accuse, resent or murmur, it is because the Spirit of Love desires nothing but itself, it is its own

[3] Dante's "ricchezza senza brama."

13

Good, for Love is God, and he that dwelleth in God dwelleth in Love." [4]

Behmen's idea of the "fallen Angels" is that they are entirely and hopelessly divided from the Life of God. They are mere embodied, hopeless, self-tormenting Desires. They have fallen into the hell within themselves, they cannot but be hating, bitter, envious, proud, wrathful, restless; and therefore tormentors of others. They have lost that which man, however far astray, always possesses, the faculty of return or regeneration through submission to and union with God. The spark of the Life and Spirit of God which is in Men is not in the fallen Angels. Let us hope that Beings so utterly lost do not exist.

God is outside of Nature and yet in a sense inside also, because there is a divine life or virtue in Nature which, longing to re-unite itself with its source, is a cause of anguish while divided, and of joy when united. So, in the outer world, the seed buried in earth contains a power kindred to the virtue of the sun. It is this which breaks forth from the seed, forces itself up through the dark, imprisoning, and yet nourishing and necessary earth, and at last, if it can win its way through obstacles, cheerfully expands in the light of the sun and feeds upon his warmth. That, in man's inner nature, which answers to this power or life in the seed, is called by Behmen the Life or Spirit of Jesus Christ. Egoism or Ihood, the old contracting, narrowing cell, is destroyed as this expansive and expanding force grows and breaks forth. Behmen says: "As the Sun in the visible world ruleth over Evil and Good, and, with its light and power, and all whatsoever itself is, is present everywhere, and penetrates into every Being, and wholly giveth itself to every Being,

[4] Law's Works, vol. viii., p. 177.

and yet ever remaineth whole, and nothing of its being goeth away therewith. Thus also it is to be understood concerning Christ's person and office which ruleth in the inward spiritual world, and penetrateth into the faithful man's soul, spirit and heart. As the Sun worketh through a herb, so that the herb becometh filled with the virtue of the Sun, and, as it were, so converted by the Sun that it becometh wholly of the nature of the Sun, so Christ ruleth in the resigned will or Soul and Body, over all evil inclinations and generateth the man to be a new heavenly creature." The same teaching is finely set forth in a passage of William Law. [5] He says:

"Man has a spark of the Light and Spirit of God, as a supernatural gift of God given into the birth of his Soul to bring forth by degrees a new birth of that life which was lost in Paradise. This holy spark of the Divine Nature within him has a natural, strong, and almost infinite tendency or reaching after that eternal Light and Spirit of God, from whence it came forth. It came forth from God, it came out of God, it partaketh of the Divine Nature, and therefore it is always in a state of tendency and return to God. All this is called the breathing, the moving, the quickening of the Holy Spirit within us, which are so many operations of this spark of life tending towards God. On the other hand the Deity as considered in itself, and without the Soul of man, has an infinite unchangeable tendency of love and desire towards the Soul of man, to unite and communicate its own riches and glories to it, just as the Spirit of the air without Man unites and communicates its riches and virtues to the Spirit of the air that is within Man. This love or desire of God toward the soul of Man is so great that he gave his only-begotten Son, the brightness of his glory, to take the human nature upon him, in its fallen state, that by this mysterious union of God and

[5] Works, vol. vii., p. 65, ed. 1765.

Man, all the enemies of the Soul of Man might be overcome, and every human creature might have a power of being born again according to that Image of God in which he was first created. The gospel is the history of this Love of God to Man. Inwardly he has a seed of the Divine Life given into the birth of his Soul, a seed that has all the riches of eternity in it, and is always wanting to come to the birth in him, and be alive in God. Outwardly he has Jesus Christ, who as a Sun of Righteousness, is always casting forth his enlivening beams on this inward seed, to kindle and call it forth to the birth, doing that to this Seed of Heaven in Man, which the sun in the firmament is always doing to the vegetable seeds in the earth.

"Consider this matter in the following similitude. A grain of wheat has the air and light of this world enclosed or incorporated in it. This is the mystery of its life, this is its power of growing, by this it has a strong continual tendency of uniting again with that ocean of light and air from whence it came forth. On the other hand that great ocean of light and air, having its own offspring hidden in the heart of the grain has a perpetual strong tendency to unite and communicate with it again. From this desire of union on both sides, the vegetable life arises and all the virtues and powers contained in it. But let it be well observed that this desire on both sides cannot have its effect till the husk and gross part of the grain falls into a state of corruption and death; till this begins, the mystery of life hidden in it cannot come forth."

The sun only acts by stirring up in each thing, and calling into activity, its own imprisoned, dormant, heat or life. Save by the same nature-process, working in an inner sphere, there cannot come to pass the flower and fruit of the Soul. The Sun, true emblem of the Redeeming Spirit, helps each vital force to break forth from its state

16

of death—even though, like the grains of wheat found in Egyptian graves and then new-planted, it has been immured there thousands of years—and to enter into its highest possible state of life. Indeed, in this school of wisdom, the natural visible light, of which the Sun is the dispensing medium to our solar system, and other suns to other circles of planets, is actually an outer manifestation of the inner supernatural light, and warmth, not a mere emblem at all. We speak more truly than we know, when we speak of a "heavenly day." All Nature is a series of "out-births" of the Deity. "The outward world," says Behmen, "is sprung out of the inward spiritual world, viz., out of Light and Darkness." And his English interpreter says: "Whatever is delightful and ravishing, sublime and glorious in spirits, minds, or bodies, either in heaven, or on earth, is from the power of the Supernatural Light opening its endless wonders in them. Hell has no misery, horror or distraction, but because it has no communication with the supernatural Light. And did not the supernatural Light stream forth its blessings into this world, through the materiality of the Sun, all outward Nature would be full of the horror of Hell." And elsewhere, "There is no meekness, benevolence or goodness in Angel, Man, or any other Creature, but where Light is the Lord of its life. Life itself begins no sooner, rises no higher, has no other glory, than as the Light begins it, and leads it on. Sounds have no softness, flowers and germs no sweetness, plants and fruits have no growth, but as the Mystery of Light opens itself in them." [6] And so Behmen himself says: "There is nothing that is created or born in Nature but it also manifests its internal form externally; for the internal continually labours or works itself forth to manifestation. We know in the power and form of this World, how the only Essence has manifested itself with the external birth in the desire of the similitude; how it has manifested

[6] Law's Works, vol. viii., p. 189.

17

itself in so many forms and shapes, which we see and know in the stars and elements, likewise in the living creatures, and also in the trees and herbs." Thus there is a real communion between all beauty, sweetness, and glory, within and without the Soul of man.

It is this truth, not of the analogy between the essential life of Man and Nature, but of the unity in all things, that is now opening itself out in many ways. Wordsworth, a true seer, has given to it its highest expression in English Poetry. Modern science all tends to confirmation of this unity.

God, then, must become Man, there must be a birth of the Life of God in the Soul, in order that the Soul may live its highest life. Only in this way can the wild properties of Nature be subordinated and turned to their proper use, their restless hunger pacified. Goodness and happiness can be expected from nothing else but from the Divine Life united to and dwelling in the Nature Life. It is the "ingrafted Word" of St James' Epistle.

The plant cannot but grow towards the sun. If it is too deep in earth, or prevented by a strong soil, or withered by dryness, so that it cannot attain to its end, the fault is not with it. But, in the spiritual inner world (in which the plant dwells not) the Soul of man has this freedom—that it can consciously turn towards God, whose Spirit and Life will then come forth to meet it, or can turn towards the Things of this World. Upon this freedom of choice is founded Behmen's moral teaching. The Soul is like a woman (and all nations have testified in their languages and parables to their sense of this) who can freely choose to submit and surrender her body to this Lover, or to that. When she has chosen her free power ends. As she has chosen, so her life-faculty will be fertilised by good or evil; so

18

will be the new life that arises within her, and so will be her future joy or sorrow.

In a deep sense, the desire of the spark of Life in the Soul to return to its Original Source is part of the longing desire of the universal Life for its own heart or centre. Of this longing the universal attraction, striving against resistance, towards an universal centre, proved to govern the phenomenal or physical world, is but the outer sheath and visible working. It has been said that Sir Isaac Newton (who was a diligent reader of Behmen's Works) "ploughed with Jacob Behmen's heifer." There is in truth but one Religion, that founded upon the eternal, immutable, universal processes of the actual Nature of things, and of this Christianity, rightly apprehended, is the supreme Revelation. This will be seen better by all as the Religion unfolds itself. Rightly speaking there is no such thing as supernatural religion; there is but one Religion, that of Nature. It is the work of visible religion to teach by signs and parables, embodying the mystery in symbols, and clothing it with adoration.

Jacob Behmen's mode of expression is all his own, and there is much in the fabric of his thought which men of our time, if they take a superficial view, would not find it easy to accept. The doctrine of Evolution now profoundly influences every corner of the field of thought. We now incline to think rather of the rise of Man out of Nature than of his fall into it, though, perhaps, there can no more be a rise without a precedent fall, than there can be a return without a precedent out-going. Evolution may be the time-form of Attraction. But all this affects the outside form, not the essence of the doctrine. Behmen is concerned with the real nature of things, apart from time and space, with their apparent, but so

misleading, facts. He appeals to each Soul's knowledge of itself, and, on the principle that all is in everything, draws from the nature of Man, that little Universe (and we can no otherwise learn things as they are in themselves), his teaching as to Universal Nature. "In Man (he says) lies all whatsoever the Sun shines upon, or Heaven contains, as also Hell and all the Deeps." His Iliad is the struggle between light and darkness, life and death, expansion and contraction, the centripetal and centrifugal force, heat and cold, love and hatred, peace and wrath, humility and pride, self-sacrifice and self-seeking, joy and anguish, repose and restlessness, in the whole of Nature and in the Soul of Man. Does not every man, who has lived his full life, know the truth and reality of all this? It is known more especially and actually by those ardent and adventurous spirits who have sailed in far seas of thought or action, not merely coasting along the shores of tradition, authority and established rule. Sinners know some things more vividly than those who ever and easily have been good. Only the man who has been sick knows the difference between sickness and health. The prodigal who had wandered in a far country and had lived as he would, understood the meaning of peace and love better than the brother who had always stayed at home.

These wanderers, if they return in time, know best, taught by the heart-rending lessons of experience, the difference between the Heaven and Hell within them; the Hell of wrath, self-torment, fear, anxiety, envy, malice, evil-will, pride, cruelty, sensual passion, longing to domineer, and the Heaven of love, benevolence, meekness, humility, compassion, peace, joy, long-suffering.

They know that Heaven and Hell can alike be revealed in the Soul. From youth they have felt something in them striving, often feebly

enough, against passionate desires for wealth, honour, success, and for mastery over the minds, affections, and bodies of others. Behind all this turmoil and ever unsatisfied anguish of seeking that which satisfies not, they have been aware of a diviner life slowly growing towards heaven, ever and again thwarted and driven back by the renewed assaults of the Spirit of the World, yet never quite destroyed. At the moments of fiercest fight against rebel passions they have felt the divine assisting strength flow into them, if only they powerfully invoked it, turning towards its source as a babe towards its mother's breast. They have heard the "Peace be still" amid the wildest spiritual storms. They know that if they have been saved, it is not by their own strength nor by reasoning, but by this power from without.

They know the impotence, in action, of the merely reflective or spectator faculty. In this sense of the word "reason," they would agree with him who wrote "Your Heart is the best and greatest gift of God to you; it is the highest, greatest, strongest, and noblest Power of your Nature; it forms your whole Life, be it what it will; all Evil and all Good comes from it; your Heart alone has the key of Life and Death; it does all that it will; Reason is but its plaything; and whether in Time or Eternity, can only be a mere Beholder of the wonders of happiness, or forms of misery, which the right or wrong working of the Heart is entered into." [7]

William Law remarks that Jesus Christ, though he had all wisdom, yet gives but a small number of doctrines to mankind "whilst every moral teacher writes volumes upon every single virtue." It is, he adds, because our Lord "knew what they know not, that our whole malady lies in this, that the Will of our Mind is turned into this

[7] Law's Works, vol. vii., p. 162.

World, and that nothing can relieve us, or set us right, but the turning of the Will of our Mind and the Desire of our Hearts to God. And hence it is that he calls us to nothing but a total denial of ourselves and the Life of this World and to faith in him as the Worker of a new birth and life in us." On this one root of the whole matter Jacob Behmen insisted, expressing one truth in a thousand ways and through images, which to him are not images but the same process working in other spheres. His whole practical, moral teaching enforces the right direction of Desire. Mali mores sunt mali amores, said one who also truly saw; the profound Augustine. The hunger of the Soul must be turned to the source of eternal joy. All that is good and beautiful in nature or in the heart of man flows from that fountain. Desire is everything in Nature; does everything. Heaven is Nature filled with divine Life attracted by Desire.

PRELIMINARY NOTE

Before entering upon the Dialogues I have thought it well to insert some sentences taken from a treatise of Behmen's called "Regeneration," together with some taken from another treatise of his on "Christ's Testament" because they show well the spirit in which he thought and wrote. The freedom of thought and expression which he claims is, happily, far more readily accorded now than it was in his own day.

I have only one thing to add. In the eighteenth century English translation of Behmen's Works, all the substantives, as was then the frequent custom, are printed with capital letters. There is a philosophic basis for this practice, because a substantive is an attempt to denote a "thing in itself" and is therefore of greater weight than an adjective, which only expresses qualities which we attribute to it. To Behmen's Works this mode of printing seems especially appropriate. In our now too literary language, many words have become so trite and carelessly used that they have almost ceased to have reference to real existing things. But Behmen never uses words in this merely literary way, being indeed in nowise a man of letters. It might have been said of him, as indeed his enemies did at the time say, that which was said by the Jews of our Lord, "How knoweth this man letters having never learned?" When he speaks of the "glory" of God, he means something as real as if he spoke of the "leaves on that tree," and so with all his words. I was therefore somewhat inclined, in order to mark this, to adhere altogether to the old custom in this case, and though I have not done so, fearing it might annoy the eye of the unaccustomed reader, I have preserved the capital letters in many cases, where it is

especially desirable to dwell on the expression of real existences by the words. It is of course an illogical compromise between two customs.

The title "Supersensual Life" is not altogether a good one, but it is that which is used in former editions of Behmen. The idea is rather of Life behind, than above, the life of sense.

Sentences Selected from Jacob Behmen's Treatises "Regeneration" and "Christ's Testaments"

1

A true Christian, who is born anew of the Spirit of Christ, is in the simplicity of Christ, and hath no strife or contention with any man about religion.

2

The Christendom that is in Babel striveth about the manner how men ought to serve God and glorify him; also, how they are to know him, and what he is in his Essence and Will. And they preach positively that whosoever is not one and the same with them in every particular of knowledge and opinion, is no Christian, but a heretic.

3

But a Christian is of no sect. He can dwell in the midst of sects, and appear in their services, without being attached or bound to any. He hath but one knowledge, and that is, Christ in him. He seeketh but one way, which is the desire always to do and teach that which is right; and he putteth all his knowing and willing into the Life of Christ. He sigheth and wisheth continually that the Will of God might be done in him, and that his Kingdom might be manifested in him. His faith is a desire after God and Goodness, which he wrappeth up in a sure hope, trusting to the words of the promise,

and liveth and dieth therein; though as to the true man, he never dieth.

4

For Christ saith: Whosoever believeth in me shall never die, but hath pierced through from death to life; and, Rivers of living water shall flow from him, viz. good doctrine and works.

5

Therefore I say that whosoever fighteth and contendeth about the Letter, is all Babel. The Letters of the Word proceed from, and stand all in, one Root, which is the Spirit of God; as the various flowers stand all in the earth, and grow about one another. They fight not with each other about their difference of colour, smell, and taste, but suffer the earth, the sun, the rain, the wind, the heat, and cold, to do with them as they please; and yet every one of them groweth in its own peculiar essence and property.

6

Even so it is with the Children of God; they have various gifts and degrees of knowledge, yet all form one Spirit. They all rejoice at the great Wonders of God, and give thanks to the Most High in his Wisdom. Why then should they contend about him in Whom they live and have their being, and of whose substance they themselves are?

7

It is the greatest folly that is in Babel for people to strive about religion, so that they contend vehemently about opinions of their

own forging, viz. about the Letter. When the Kingdom of God consisteth of no Opinion, but in Power and Love.

8

As Christ said to his disciples, and left it with them at the last, saying: Love one another as I have loved you: for thereby men shall know that ye are My disciples. If men would as fervently seek after love and righteousness as they do after opinions, there would be no strife on earth, and we should be as children of one father, and should need no law or ordinance. For God is not served by any law, but only by obedience. Laws are for the wicked, who will not enhance love and righteousness; they are, and must be, compelled by laws.

9

We all have but one Order, Law, or Ordinance, which is to stand still to the Lord of all Beings, and resign our wills up to him, and suffer his Spirit to play what music he will. And thus we give to him again as his own fruits that which he worketh and manifesteth in us.

10

Now if we did not contend about our different fruits, gifts, kinds, and degrees of knowledge, but did acknowledge them in one another, like Children of the Spirit of God, what could condemn us? For the Kingdom of God consisteth not in our knowing and supposing, but in Power.

11

If we did not know half so much, and were more like children, and had but a brotherly mind and goodwill towards one another, and lived like children of one mother, and as branches of one tree, taking our Sap all from one Root, we should be far more holy than we are.

12

Knowledge serves only to this end, viz., to know that we have lost the Divine Power in Adam, and are now become inclined to sin; that we have evil properties in us, and that doing evil pleaseth not God; so that with our knowledge we learn to do right. Now if we have the Power of God in us, and desire with all our hearts to act and to live aright, then our knowledge is but our sport, or matter of pleasure, wherein we rejoice.

13

For true knowledge is the manifestation of the Spirit of God through the Eternal Wisdom. He knoweth what he will in his children; he sheweth his wisdom and wonders by his children, as the earth putteth forth her various flowers.

14

Now if we dwell with one another, like humble children, in the Spirit of Christ, are rejoicing at the gift or knowledge of another, who would judge or condemn us? Who judgeth or condemneth the birds in the woods that praise the Lord of all Beings with various voices, every one in its own essence? Doth the Spirit of God reprove them for not bringing their voices into one harmony? Doth not the

melody of them all proceed from his Power, and do they not sport before him?

15

Those men therefore that strive and wrangle about the knowledge and will of God, and despise one another on that account, are more foolish than the birds in the woods, and the wild beasts that have no true understanding. They are more unprofitable in the sight of the holy God than the flowers of the field, which stand still in quiet submission to the Spirit of God, and suffer him to manifest the Divine Wisdom and Power through them.

16

All Christian Religion consisteth wholly on this, to learn to know ourselves; whence we came, and what we are; how we are gone forth from the Unity into dissension, wickedness, and unrighteousness; how we have awakened and stirred up these evils in us; and how we may be delivered from them again, and recover our original blessedness.

17

First; How we were in the Unity, when we were the Children of God in Adam before he fell. Secondly; How we are now in dissension and disunion, in strife and contrariety. Thirdly; Whither we go when we pass out of this corruptible condition; whither with the unnatural, and whither with the natural part. And lastly; How we came forth from disunion and vanity, and enter into that one Tree, Christ in us, out of which we all sprung in Adam. In these four points all the necessary knowledge of a Christian consisteth.

18

So that we need not strive about any thing; we have no cause of contention with each other. Let every one only exercise himself in learning how he may enter again into the Love of God and his Brother.

19

The written Word is but an instrument whereby the Spirit leadeth us to itself within us. That Word which will teach must be living in the literal Word. The Spirit of God must be in the literal sound, or else none is a Teacher of God, but a mere Teacher of the Letter, a knower of the history, and not of the Spirit of God in Christ.

20

All that men will serve God with must be done in Faith, viz. in the Spirit. It is the Spirit that maketh the work perfect, and acceptable in the sight of God. All that a man undertaketh and doeth in Faith, he doth in the Spirit of God, which Spirit of God doth co-operate in the work, and then it is acceptable to God. For he hath done it himself, and his Power and Virtue is in it. It is holy.

21

Strife and misunderstanding concerning Christ's Person, Office, and Being, or Substance, as also concerning his Testaments which he left behind him, wherein he worketh at present, ariseth from the deflected creaturely Reason, which runneth on only in an Image-like opinion, and reacheth not the ground of this mystery, and yet will be a mistress of all things or beings, and will judge all things. It doth but lose itself in such Image-likeness, and breaketh itself off

from its Centre, and disperseth the thoughts, and runneth on in the multiplicity, whereby its ground is confused and the mind is disquieted, and knoweth not itself.

22

No Life can stand in certainty, except it continue in its Centre, out of which it is sprung.

23

When the Soul that is sprung from God's Word and Will is entered into its own desire to will of itself, it will run in mere uncertainty till it return to its Original again.

24

Seeing that human life is an outflowing of the Divine Power, Understanding and Skill, the same ought to continue in its Original, or else it loseth the Divine Knowledge, Power and Skill, and with self-speculation bringeth itself into centres of its own, and strange imaging, wherewith its Original becometh darkened and strange.

Therefore say I, that this is the only cause that men dispute about God, his Word, Essence or Being, and Will, that the understanding of man hath broken itself off from its Original, and now runneth on in mere self-will, thoughts and images in its own lust to selfishness, wherein there is no true knowledge, nor can be, till the Life returneth to its Original, viz. into the Divine Outflowing and Will.

25

If this be done, then God's Will speaketh forth the Divine Power and Wonders again through the human willing. In which Divine Speaking, the Life may know and comprehend God's Will, and frame itself therein. Then there is true Divine Knowledge and Understanding in man's skill, when his skill is continually renewed with Divine Power.

26

As Christ hath taught us when he said, Unless ye be converted and become as a Child, ye shall not come into the Kingdom of God. That is, that the Life turn itself again unto God out of whom it is proceeded, and forsake all its own imaging and lust, and so come to the Divine Vision again.

27

All disputation concerning God's Being or Essence or Will is performed in the images of the senses or thoughts without God. For if any liveth in God, and willeth with God, what needeth he dispute about God, who, or what God is? That he disputeth about it is a sign that he hath never felt it at all in his mind or senses, and it is not given to him that God is in him, and willeth in him what he will. It is a certain sign that he exalts his own meaning and image above others, and desireth dominion.

28

Men should friendly confer together, and offer one another their gifts and knowledge in love, and try things one with another, and hold that which is best, and not so stand in their own opinion as if

they could not err. It lyeth in no man's person that men should suppose that the Divine Understanding must come only from such and such. For the Scripture says, Try all things and hold that which is good, 1 Thess. v. 21.

29

The touchstone to true knowledge is first, the Corner-stone, Christ; that men should see whether a thing enter out of love into love, or whether alone purely the love of God be sought and desired; whether it be done out of humility or pride; Secondly, whether it be according to the Holy Scripture; Thirdly, is it according to the human heart and soul, wherein the Book of the Life of God is incorporated, and may very well be read by the Children of God? Here the true mind hath its touchstone in itself, and can distinguish all things. If it be so that the Holy Ghost dwell in the ground of the mind, that man hath touchstone enough; that will lead him into all truth.

30

All strife concerning Christ's testaments cometh hence that men do not understand that Heaven wherein Christ sitteth at the right hand of God. They understand not that he is in this World, and that the World standeth in Heaven, and Heaven in the World, and are in one another, as Day and Night.

1 Cor. ii. 7, 8, 9, 10, 11, 12, 13, 14, 15.

We speak the hidden mystical wisdom of God; which God ordained before the world into our glory; which none of the Princes of this World knew. For had they known it, they would not have crucified the Lord of Glory. But, as it is

written, Eye hath not seen nor ear heard, neither hath it entered into the heart of man to conceive the things which God hath prepared for them that love him. But God hath revealed them unto us by his Spirit. For the Spirit searcheth all things, yea the deep things of God. Now we have received, not the Spirit of the World, but the Spirit which is of God; that we might know the things that are freely given us of God. Which things also we speak, not in the words which men's wisdom teacheth, but which the Holy Ghost teacheth; comparing spiritual things with spiritual. But the Natural Man receiveth not the things of the Spirit of God; for they are foolishness unto him; neither can he know them, because they are spiritually discerned. But he that is spiritual judgeth, or discerneth all things.

OF THE SUPERSENSUAL LIFE IN DIALOGUES
BETWEEN A SCHOLAR OR DISCIPLE
AND HIS MASTER

DIALOGUE I

The Disciple said to his Master: Sir, how may I come to the Supersensual Life, so that I may see God, and may hear God speak?

The Master answered and said: Son, when thou canst throw thyself into THAT, where no Creature dwelleth, though it be but for a moment, then thou hearest what God speaketh?

Disciple

Is that where no Creature dwelleth near at hand, or is it afar off?

Master

It is in thee. And if thou canst, my Son, for a while but cease from all thy thinking and willing, then thou shalt hear the unspeakable words of God.

Disciple

How can I hear him speak, when I stand still from thinking and willing?

Master

When thou standest still from the thinking of Self, and the willing of Self. When both thy intellect and will are quiet, and passive to the expressions of the Eternal Word and Spirit; and when thy soul is winged up and above that which is temporal, the outward senses and the imagination being locked up by holy abstraction, then the Eternal Hearing, Seeing and Speaking will be revealed in thee, and so God heareth and seeth through thee, being now the organ of his Spirit, and so God speaketh in thee, and whispereth to thy Spirit, and thy Spirit heareth his voice. Blessed art thou therefore if thou canst stand still from self-thinking and self-willing, and canst stop the wheel of thy imagination and senses; forasmuch as hereby thou mayest arrive at length to see the great Salvation of God, being made capable of all manner of divine sensations and heavenly communications. Since it is nought indeed but thine own hearing and willing that do hinder thee, so that thou dost not see and hear God.

Disciple

But wherewith shall I hear and see God, forasmuch as he is above Nature and Creature?

Master

Son, when thou art quiet and silent, then art thou as God was before Nature and Creature; thou art that which God then was; thou art that whereof he made thy nature and creature. Then thou hearest and seest even that wherewith God himself saw and heard in thee, before ever thine own willing or thine own seeing began.

36

Disciple

What now hinders or keeps me back, so that I cannot come to that, wherewith God is to be seen and heard?

Master

Nothing truly but thine own willing, hearing, and seeing do keep thee back from it, and do hinder thee from coming to this supersensual state. And it is because thou strivest so against that, out of which thou thyself art descended and derived, that thou thus breakest thyself off, with thine own willing, from God's willing, and with thine own seeing from God's seeing. In as much as in thine own seeing thou dost see in thine own willing only, and with thine own understanding thou dost understand but in and according to thine own willing, as the same stands divided from the Divine Will. This thy willing, moreover, stops thy hearing, and maketh thee deaf towards God, through thy own thinking upon terrestrial things, and thy attending to that which is without thee, and so it brings thee to a ground where thou art laid hold on and captivated in Nature. And having brought thee hither, it overshadows thee with that which thou willest, it binds thee with thine own chains, and it keeps thee in thine own dark prison which thou makest for thyself, so that thou canst not go out thence, or come to that state which is Supernatural and Supersensual.

Disciple

But being I am in Nature, and thus bound as with my own chains, and by my own natural will, pray be so kind, Sir, as to tell me, how

37

I may come through Nature into the Supersensual and
Supernatural Ground, without the destroying of Nature?

Master

Three things are requisite in order to this. The first is, Thou must
resign up thy Will to God, and must sink thyself down to the dust
in his mercy. The second is, Thou must hate thy own Will, and
forbear from doing that to which thy own Will doth drive thee. The
third is, Thou must bow thy soul under the Cross, heartily
submitting thyself to it, that thou mayst be able to bear the
temptations of Nature and Creature. And if thou dost this, know
that God will speak unto thee, and will bring thy resigned Will into
Himself, in the supernatural ground, and then thou shalt hear, my
son, what the Lord speaketh in thee.

Disciple

This is a hard saying, Master, for I must forsake the World and my
life too, if I should do thus.

Master

Be not discouraged hereat. If thou forsakest the World, then thou
comest unto that out of which the World is made, and if thou losest
thy life, then thy life is in that for whose sake thou forsakest it. Thy
life is in God, from whence it came into the body, and as thou
comest to have thine own power faint and weak and dying, the
power of God will then work in thee and through thee.

Disciple

Nevertheless, as God hath created man in and for the natural life, to rule over all creatures on earth, and to be a lord over all things in this world, it seems not to be at all unreasonable that God should therefore possess this world and the things therein for his own.

Master

If thou rulest over all creatures but outwardly there cannot be much in that. But if thou hast a mind to possess all things, and to be a lord indeed over all things in this world, there is quite another method to be taken by thee.

Disciple

Pray, how is that? And what method must I take, whereby to arrive at this sovereignty?

Master

Thou must learn to distinguish between the Thing, and that which is only an image thereof; between that sovereignty which is substantial and in the inward ground of Nature, and that which is imaginary and in outward form of semblance; between that which is properly angelical and that which is no more than bestial. If thou rulest over the creatures externally only and not from the right internal ground of thy inward nature, then thy will and ruling is in a bestial kind or matter, and thine at best is but a sort of imaginary and transitory government, being void of that which is substantial and permanent, that which only thou art to desire and press after.

Thus by thy outward lording it over the creatures it is most easy for thee to lose the substance and the reality, whilst thou hast naught remaining but the image and shadow only of thy first and original lordship wherein thou art made capable to be again invested, if thou art but wise, and takest thy investiture from the Supreme Lord in the right course and matter. Whereas by thy willing and ruling them in a bestial manner, thou bringest also thy desire into a bestial essence, by which means thou becomest infected and captivated therein, and gettest therewith a bestial nature and condition of life. But if thou shalt have put off the bestial nature, and left the imaginary life, and quitted the low-imaged condition of it, then art thou come into the super-imaginariness and into the intellectual life, which is a state of living above images, figures and shadows. And so thou rulest over all creatures, being re-united with thy Original, in that very ground or source, out of which they were and are created, and thenceforth nothing on earth can hurt thee. For thou art like All Things, and nothing is unlike thee.

Disciple

O loving Master, pray teach me how I may come the shortest way to be like unto All Things.

Master

With all my heart. Do but think on the words of our Lord Jesus Christ when he said: "Except ye be converted and become as little children ye shall not enter into the kingdom of heaven." There is no shorter way than this, nor can a better way be found. Verily, Jesus saith unto thee, Unless thou turn and become as a child, hanging upon him for all things, thou shalt not see the Kingdom of God.

40

This do and nothing shall hurt thee; for thou shalt be at friendship with all the things that are, as thou dependest upon the author and fountain of them, and becomest like him, by such dependence, and by the Union of thy Will with his Will. But mark what I have further to say, and be not thou startled at it, though it may seem hard for thee at first to conceive. If thou wilt be like All Things thou must forsake all things; thou must not extend thy will to possess that for thine own, or as thine own, which is Something, whatever that Something be. For as soon as ever thou takest Something into thy desire, and receivest it into thee for thine own, or in propriety, then this very Something (of what nature soever it is) is the same with thyself; and this worketh with thee in thy will, and thou art thence bound to protect it, and take care of it, even as of thy own being. But if thou dost receive no thing into thy desire then thou art free from all things, and rulest over all things at once, as a Prince of God. For thou hast received nothing for thine own, and art nothing to all things, and all things are as nothing unto thee. Thou art as a child, which understands not what a thing is; and though thou dost perhaps understand it, yet thou understandest it without mixing with it, and without it sensibly affecting or touching thy perception, even in that matter wherein God doth rule and see all things, he comprehending All, and yet nothing comprehending him.

Disciple

Ah! how shall I arrive at this heavenly understanding, at this pure and naked knowledge, which is abstracted from the senses, at this light above Nature and Creature, and at this participation of the Divine Wisdom which oversees all things, and governs through all intellectual beings? For, alas, I am touched every moment by the things which are about me, and overshadowed by the clouds and

41

perfumes which rise up out of the earth. I desire, therefore, to be taught, if possible, how I may attain such a state and condition as that no creature may be able to touch me to hurt me; and how my mind, being purged from sensible objects and things, may be prepared for the entrance and habitation of the Divine Wisdom in me.

Master

Thou desirest that I would teach thee how thou art to attain it; and I will direct thee to our Master, from whom I have been taught it, that thou mayest learn it thyself from him, who alone teacheth the heart. Hear thou him. Wouldst thou arrive at this; wouldst thou remain untouched by sensibles; wouldst thou behold light in the very Light of God, and see all things thereby; then consider the words of Christ, who is the Light and who is the Truth. O consider now his words, who said, Without me ye can do nothing (John xix. 5) and defer not to apply thyself unto him, who is the strength of thy salvation, and the power of thy life; and with whom thou canst do all things, by the faith which he waketh in thee. But unless thou wholly givest thyself up to the life of our Lord Jesus Christ, and resignest thy Will wholly to him, and desirest nothing and willest nothing without him, thou shalt never come to such a rest as no creature can disturb. Think what thou pleasest, and be never so much delighted in the activity of thine own reason, thou shalt find that, in thine own power and without such a total surrender to God and to the life of God, thou canst never arrive at such a rest as this, or the true Quiet of the Soul, wherein no creature can molest thee, or even so much as touch thee. Which when thou shalt, with Grace, have attained to, then with thy Body thou art in the World, as in the properties of outward Nature; and, with thy Reason, under the

42

Cross of our Lord Jesus Christ; but with thy Will thou walkest in heaven, and art at the end from whence all creatures are proceeded forth, and to which they return again. And then thou canst in this End, which is the same with the Beginning, behold all things outwardly with reason and liberally with the mind; and so mayest thou rule in all things and over all things, with Christ; unto whom all power is given both in heaven and on earth.

Disciple

O, Master, the creatures which live in me do withhold me, so that I cannot so wholly yield and give up myself as I willingly would. What am I to do in this case?

Master

Let not this trouble thee. Doth thy Will go forth from the creatures? Then the creatures are forsaken in thee. They are in the world, and thy body, which is in the world, is with the creatures. But spiritually thou walkest with God, and conversest in heaven; being in thy mind redeemed from earth, and separated from creatures, to live the life of God. And if thy Will thus leaveth the creatures, and goeth forth from them, even as the spirit goeth forth from the body at death; then are the creatures dead in it, and do live only in the body in the world. Since if thy Will do not bring itself into them, they cannot bring themselves into it, neither can they by any means touch the soul. And hence St Paul saith, Our conversation is in heaven; and also, Ye are the temple of God, and the Spirit of God dwelleth in you. So, then, true Christians are the very temples of the Holy Ghost, who dwelleth in them; that is, the Holy Ghost dwelleth in the Will, and the Creature dwelleth in the Body.

Disciple

If now the Holy Spirit doth dwell in the Will of the Mind, how ought I to keep myself so that he depart not from me again.

Master

Mark, my son, the words of our Lord Jesus Christ: If ye abide in my words, then my words abide in you. If thou abidest with thy Will in the Words of Christ; then his Word and Spirit abideth in thee, and all shall be done for thee that thou canst ask of him. But if thy Will goeth into the creature, then thou hast broken off thyself thereby from him. And then thou canst not any otherwise keep thyself but by abiding continually with that resigned humility, and by entering into a constant course of penitence, wherein thou wilt always be grieved at thine own creaturely Will, and that creatures do still live in thee, that is, in thy bodily appetite. If thou dost thus, thou standest in a daily dying from the creatures, and in a daily ascending into heaven in thy will, which will is also the Will of thy Heavenly Father.

Disciple

O my loving Master, pray teach me how I may come to such a constant course of holy penitence, and to such a daily dying from all creaturely objects, for how can I abide continually in repentance?

Master

When thou leavest that which loveth thee, and lovest that which hateth thee; then thou mayest continually abide in repentance.

Disciple

What is it that I must thus leave?

Master

All things that love and entertain thee, because thy Will loves and entertains them. All things that please and feed thee, because thy Will feeds and cherishes them. All creatures in flesh and blood; in a word, all visibles and sensibles, by which either the imaginative or sensitive appetite in men are delighted and refreshed. These the Will of thy mind, or thy supreme part, must leave and forsake, and must even account them all its enemies. This is the leaving of what loves thee. And the loving of what hates thee is the embracing the reproach of the World. Thou must learn then to love the Cross of the Lord Jesus Christ, and for his sake to be pleased with the reproach of the World which hates thee and derides thee; and let this be thy daily exercise of penitence to be crucified to the World, and the World to thee. And so thou shalt have continual cause to hate thyself in the Creature, and to seek the eternal rest which is in Christ. To which rest thou having thus attained, thy Will may therein safely rest and repose itself, according as thy Lord Christ hath said: In me ye may have rest, but in the World ye shall have anxiety: In me ye may have peace, but in the World ye shall have tribulation.

Disciple

How now shall I be able to subsist in this anxiety and tribulation arising from the World so as not to lose the eternal peace, or not to enter into this rest? And how may I recover myself in such a

temptation as this is, by not sinking under the World, but rising above it by a life which is truly heavenly and supersensual?

Master

If thou dost once every hour throw thyself by faith beyond all creatures, beyond and above all sensual perception and apprehension, yea, above discourse and reasoning into the abyssal mercy of God, into the sufferings of our Lord, and into the fellowship of his interceding, and yieldest thyself fully and absolutely thereinto; then thou shalt receive power from above to rule over Death and the Devil and to subdue Hell and the World unto thee. And then thou mayest subsist in all temptations, and be the brighter for them.

Disciple

Blessed is the man that arriveth to such a state as this. But, alas, poor man that I am, how is this possible as to me? And what, O my Master, would become of me, if I should ever attain with my mind to that where no creature is? Must I not cry out, I am undone?

Master

Son, why art thou so dispirited? Be of good heart still; for thou mayest certainly yet attain to it. Do but believe, and all things are made possible to thee. If it were that thy Will, O thou of so little courage, could break off itself for an hour, or even but for a half hour, from all creatures, and plunge itself into that where no creature is, or can be; presently it would be penetrated and clothed upon with the supreme splendour of the Divine Glory, would taste

in itself the most sweet Love of Jesus, the sweetness whereof no tongue can express, and would find in itself the unspeakable words of our Lord concerning his great mercy. Thy spirit would then feel in itself the Cross of our Lord Jesus Christ to be very pleasing to it; and would thereupon love the Cross more than the honours and goods of the World.

Disciple

This for the Soul would be exceeding well indeed. But what would then become of the Body, seeing that it must of necessity live in Creature?

Master

The body would by this means be put into the imitation of our Lord Jesus Christ and of his body. It would stand in the communion of that most blessed Body, which is the true temple of the Deity, and in the participation of all its gracious effects, virtues, and influences. It would live in the Creature, not of choice, but only as it is made subject to vanity, and in the World, as it is placed therein by the ordination of the Creator, for its cultivation and higher advancement, and as groaning to be delivered out of it in God's time and manner, for its perfection and resuscitation in eternal liberty and glory, like unto the glorified body of our Lord and his risen Saints.

Disciple

But the body, being in its present constitution, so made subject to vanity, and living in a vain image and creaturely shadows

47

according to the life of the undergraduated creatures or brutes, whose breath goeth downward to the earth; I am still very much afraid thereof, lest it should continue to depress the mind which is lifted up to God, by hanging as a dead weight thereto; and go on to abuse and perplex the same, as formerly, with dreams and trifles, by letting in the objects from without, in order to draw me down into the World and the hurry thereof; whereas I would fain maintain by conversation in Heaven even while I am living in the World. What, therefore, must I do with this body, that I may be able to keep up so desirable a conversation, and not to be under subjection to it any longer?

Master

There is no other way for thee that I know but to present the body whereof thou complainest (which is the beast to be sacrificed) a living sacrifice, holy and acceptable unto God. And this shall be thy rational service whereby this thy body will be put, as thou desirest, into the imitation of Jesus Christ, who said his Kingdom was not of this World. Be not thou then conformed to it, but be transformed by the renewing of thy mind; which renewed mind is to have dominion over the body, that so thou mayest prove, both in body and mind, what is the perfect Will of God, and accordingly perform the same with and by his grace operating in thee. Whereupon the body, or the animal life would, being thus offered up, begin to die, both from without and from within. From without, that is, from the vanity and evil customs and fashions of the World; it would be an utter change to all the parts thereof, and to all the pageantry, pride, ambition, and haughtiness therein. From within it would die as to all the lusts and appetites of the flesh, and would get a mind and will wholly new for its government and management; being now

48

made subject to the Spirit, which would continually be directed to God. And thus thy very body is become the temple of God and of his Spirit, in imitation of thy Lord's Body.

Disciple

But the World would hate it and despise it for so doing, seeing it must hereby contradict the World, and must live and act quite otherwise than the World doth. This is most certain. And how can this be taken?

Master

It would not take that as any harm done to it, but would rather rejoice that it is become worthy to be like unto the image of our Lord Jesus Christ, being transformed from that of the World. And it would be most willing to bear that cross after our Lord, merely that our Lord might bestow upon it the influence of his sweet and precious love.

Disciple

I do not doubt but in some this may be even so. Nevertheless, for my own part, I am in a strait between two, not feeling yet enough of that blessed influence upon me. Oh how willingly should my body bear that, could this be safely depended upon by me! Wherefore pardon me, loving Sir, in this one thing, if my impatience doth still further demand, "What would become of it, if the anger of God from within, and the wicked World also from without, should at once assault it, as the same really happened to our Lord Christ?"

Master

Be that unto it, even as unto our Lord Christ, when he was reproached, reviled and crucified by the World, and when the anger of God so fiercely assaulted him for our sake. Now what did he under this most terrible assault both from without and within? Why; he commended his soul into the hands of his Father, and so departed from the anguish of this World into the eternal joy. Do thou likewise, and his death shall be thy life.

Disciple

Be it unto me as unto the Lord Christ, and unto my body as unto his, which into his hands I have commended, and for the sake of his name do offer up, according to his revealed Will. Nevertheless I am desirous to know what would become of my body in its pressing forth from the anguish of this miserable World into the power of the Heavenly Kingdom.

Master

It would get forth from the reproach and contradiction of the World by a conformity to the passion of Jesus Christ; and from the sorrows and pains in the flesh, which are only the effects of some sensible impression of things without, by a quiet introversion of the spirit and secret communion with the Deity manifesting itself for that end. It would penetrate into itself; it would sink into the great love of God; it would be sustained and refreshed by the most sweet name Jesus, and it would see and find within itself a new world springing forth, as through the anger of God, into the joy and love eternal. And then should a man wrap his soul in this, even in the

great Love of God, and clothe himself therewith as with a garment; and should account thence all things alike; because in the Creature he finds nothing that can give him, without God, the least satisfaction, and because also nothing of harm can touch him more while he remains in this Love. For this Love is indeed stronger than all things, and makes a man invulnerable both from within and without, by taking out the sting and poison of the Creature, and destroying the power of death. And whether the body be in hell or on earth, all is alike to him; for whether it be there or here, his mind is still in the greatest Love of God; which is no less than to say that he is in heaven.

Disciple

But how would a man's body be maintained in the World; or how would he be able to maintain those who are his, if he should by such a conversation incur the displeasure of all the World?

Master

Such a man gets greater favours than the world is able to bestow upon him: he hath God for his friend; he hath all the Angels for his friends. In all dangers and necessities these protect and relieve him; so that he need fear no manner of evil; no creature can hurt him. God is his helper, and that is sufficient. Also God is his blessing in everything. And though sometimes it may seem as if God would not bless him, yet is this but for a trial to him, and for the attraction of the Divine Love, to the end he may more fervently pray to God, and commit all his ways unto him.

Disciple

He loses, however, by this all his good friends, and there will be none to help him in his necessity.

Master

Nay, but he gets the hearts of all his good friends into his possession, and loses none but his enemies, who before loved his vanity and wickedness.

Disciple

How is it that he can get his good friends into his possession?

Master

He gets the very hearts and souls of all those that belong to our Lord Jesus to be his brethren, and the members of his own very life. For all the children of God are but one in Christ, which one is Christ in All. And therefore he gets them all to be his fellow-members in the Body of Christ, whence they have all the same heavenly goods in common and all live in one and the same Love of God, as the branches of a tree in one and the same root, and spring all from one and the same source of life in them. So that he can have no want of spiritual friends and relations, who are all rooted with him together in the Love which is from above, who are all of the same blood and kindred in Christ Jesus; and who are cherished all by the same quickening sap and spirit diffusing itself through them universally from the one true Vine, which is the tree of life and love. These are friends worth having; and though here they may be unknown to

him, will abide his friends beyond doubt to all eternity. But neither can he want even outward natural friends, as our Lord Christ, when on earth, did not want such also. For though, indeed, the High-Priests and Potentates of the World could not have a love to him, because they belonged not to him, neither stood in any kind of relation to him, as being not of this world, yet those loved him who were capable of his love, and receptive of his words. So, in like manner, those who love truth and righteousness will love that man, and will associate themselves unto him, yea, though they may perhaps be outwardly at some distance or seeming disagreement, from the situation of their worldly affairs, or from other reasons, yet in their hearts they cannot but cleave to him. For though they be not actually incorporated into one body with him, yet they cannot resist being of one mind with him, and being united in affliction, for the great regard they bear to the truth, which shines forth in his words and in his life. By this they are made either his declared or his secret friends; and he doth so get their hearts that they will be delighted above all things in his company, for the sake thereof, and will court his friendship and will come unto him by stealth, if openly they dare not, for the benefit of his conversation and advice; even as Nicodemus did to Christ, who came to him by night, and in his heart loved Jesus for the truth's sake, though outwardly he feared the World. And thus thou shalt have many friends that are not known to thee; and some known to thee, who may not appear so before the World.

Disciple

Nevertheless it is very grievous to be generally despised of the World, and to be trampled upon by men as the very offscouring thereof.

Master

That which now seems so hard and heavy to thee, thou wilt yet hereafter be most in love with.

Disciple

How can it ever be that I should love that which hates me?

Master

Though thou lovest the Earthly Wisdom now, yet when thou shalt be clothed upon with the Heavenly Wisdom, then wilt thou see that all the wisdom of the World is folly; and wilt see also that the World hates not so much thee, as thine enemy, which is this mortal life. And when thou thyself shalt come to hate the will thereof, by means of a habitual separation of thy mind from the World, then thou also wilt begin to love that despising of the mortal life, and the reproach of the World for Christ's sake. And so shalt thou be able to stand under every temptation, and to hold out to the end by the means hereof in a course of life above the World and above sense.

In this course thou wilt hate thyself, and thou wilt also love thyself, I say, love thyself, and that even more than thou ever didst yet.

Disciple

But how can these two subsist together, that a person should both love and hate himself?

In loving thyself, thou lovest not thyself as thine own, but thou lovest the divine ground in thee, as given thee from the Love of God. By which, and in which, thou lovest the Divine Wisdom, the Divine Goodness, the Divine Beauty; thou lovest also by it God's works of wonders; and in this ground thou lovest also thy brethren. But in hating thyself, thou hatest only that which is thine own, and wherein the Evil sticks close to thee. And this thou dost, that so thou mayest wholly destroy that which thou callest thine, as when thou sayest I or MYSELF do this, or do that. All which is wrong and a downright mistake in thee; for nothing canst thou properly call thine but the evil Self, neither canst thou do anything of thyself that is to be accounted of. This Self therefore thou must labour wholly to destroy in thee, that so thou mayest become a ground wholly divine. There can be no selfishness in love; they are opposite to each other. Love, that is, Divine Love (of which only we are now discoursing), hates all Egoity, hates all that which we call I, or IHOOD, hates all such restrictions and confinements, even all that springs from a contracted spirit, or this evil Self-hood, because it is an hateful and deadly thing. And it is impossible that these two should stand together, or subsist in one person; the one driving out the other by a necessity of nature. For Love possesses Heaven, and dwells in itself, which is dwelling in Heaven; but that which is called I, this vile self-hood, possesses the world and worldly things; and dwells also in itself, which is dwelling in Hell, because this is the very root of Hell itself. And, therefore, as Heaven rules the World, and as Eternity rules Time, even so ought Love to rule the natural temporal Life; for no other method is there, neither can there be of attaining to that Life which is supernatural and eternal, and which thou so much desirest to be led into.

Disciple

Loving Master, I am well content that this Love should rule in me over the natural Life, that so I may attain to that which is supernatural and supersensual; but, pray tell me now, why must Love and Hatred, friend and foe, thus be together? Would not Love alone be better? Wherefore, I say, are Love and Trouble thus joined?

Master

If Love dwelt not in Trouble, it could have nothing to love. But its substance which it loves, namely the poor soul, being in trouble and pain, it hath thence cause to love this its own substance and to deliver it from pain, that so itself may by it be again beloved. Neither could any one know what Love is, if there were no Hatred; or what friendship is, if there were no foe to contend with. Or, in one word, if Love had not something which it might love, and manifest the virtue and power of love in working out deliverance to the Beloved from all pain and trouble.

Disciple

Pray what is the virtue, the power, the height, and the greatness of Love?

Master

The virtue of Love is nothing and all, or that Nothing visible out of which All Things proceed. Its power is through All Things; its height is as high as God; its greatness is as great as God. Its virtue is the principle of all principles; its power supports the Heavens and

upholds the Earth; its height is higher than the highest Heavens, and its greatness is even greater than the very Manifestation of the Godhead in the glorious light of the Divine Essence, as being infinitely capable of greater and greater manifestations in all Eternity. What can I say more? Love is higher than the Highest. Love is greater than the Greatest. Yea, it is in a certain sense greater than God; while yet, in the highest sense of all, God is Love, and Love is God. Love being the highest principle is the virtue of all virtues; from whence they flow forth. Love, being the greatest Majesty, is the Power of all Powers, from whence they severally operate. And it is the Holy Magical Root, a Ghostly Power from whence all the wonders of God have been wrought by the hands of his elect servants, in all their generations successively, Whosoever finds it, finds Nothing and All Things.

Disciple

Dear Master, pray tell me how I may understand this?

Master

First, then, in that I said, its virtue is Nothing, or that Nothing which is the beginning of All Things, thou must understand it thus; When thou art gone forth wholly from the Creature, and from that which is visible; and art become Nothing to all that is Nature and Creature, then thou art in that Eternal One, which is God himself; and then thou shalt perceive and feel within thee the highest virtue of Love. But in that I said, Its power is through All Things, this is that which thou perceivest and findest in thy own soul and body experimentally, whenever this great Love is enkindled within thee; seeing that it will burn more than the fire can do, as it did in the

Prophets of old, and afterwards in the Apostles, when God conversed with them bodily, and when his Spirit descended upon them in the Oratory of Zion. Thou shalt then see also in all the works of God, how Love hath poured forth itself into all things, and penetrated all things, and is the most inward and most outward ground in all things. Inwardly in the virtue and power of every thing, and outwardly in the figure and form thereof.

And in that I said, Its height is as high as God; thou mayest understand this in thyself: forasmuch as it brings thee to be as high as God himself is, by being united to God; as may be seen by our beloved Lord Jesus Christ in our humanity. Which humanity Love hath brought up into the highest throne, above all angelical principalities and powers, into the very Power of the Deity itself.

But in that I also said, Its greatness is as great as God, thou art hereby to understand that there is a certain greatness and latitude of heart in Love, which is unexpressible, for it enlarges the soul as wide as the whole Creation of God. And this shall be truly experienced by thee, beyond all words, when the throne of Love shall be set up in thy heart.

Moreover in that I said, Its virtue is the principle of all principles; hereby it is given thee to understand that Love is the principal cause of all created beings, both spiritual and corporeal, by virtue whereof the second causes do move and act occasionally, according to certain Eternal Laws, from the beginning implanted in the very constitution of things thus originated. This virtue which is in Love is the very life and energy of all the principles of Nature, superior and inferior. It reaches to all Worlds, and to all manner of beings in them contained, they being the workmanship of Divine Love, and is

the first mover and first moveable, both in heaven above, and in the earth beneath, and in the water under the earth. And hence there is given to it the name of the Lucid Aleph or Alpha; by which is expressed the beginning of the Alphabet of Nature, and of the Book of Creation and Providence or the Divine Archetypal Book, in which is the Light of Wisdom and the source of all lights and forms.

And in that I said, Its power supports the Heavens; by this thou wilt come to understand that as the Heavens, visible and invisible, are originated from this great principle, so are they likewise necessarily sustained by it; and that therefore if this should be but never so little withdrawn, all the lights, glories, beauties and forms of the heavenly worlds would presently sink into darkness and chaos.

And whereas I further said that it upholds the Earth; this will appear to thee no less evident than the former, and thou shalt perceive it in thyself by daily and hourly experience; forasmuch as the Earth without it, even thy own earth also (that is, thy body) would certainly be without form and void. By the power thereof the Earth hath been thus long upheld, notwithstanding a foreign usurped power introduced by the folly of sin. And should this but once fail or recede there could be no longer either vegetation or animation upon it; yea, the very pillars of it being overthrown quite, and the band of union, which is that of attraction or magnetism, called the centripetal power, being broken and dissolved, all must thence run into the utmost disorder, and falling away as into shivers, would be dispersed as loose dust before the wind.

But in that I said, Its height is higher than the highest Heavens; this

thou mayest also understand within thyself. For shouldest thou ascend in spirit through all the orders of Angels and heavenly Powers, yet the Power of Love still is undeniably superior to them all. And as the Throne of God, who sits upon the Heaven of Heavens, is higher than the highest of them, even so must Love also be, which fills them all, and comprehends them all.

And whereas I said of the Greatness of Love that it is greater than the very Manifestation of Godhead in the light of the Divine Essence; that is also true. For Love enters even into that where the Godhead is not manifested in this glorious light, and where God may be said not to dwell. And entering thereinto, Love begins to manifest to the soul the light of the Godhead; and thus is the darkness broken through, and the wonders of the new creation successively manifested.

Thus shalt thou be brought to understand really and fundamentally what is the virtue and the power of Love, and what the height and greatness thereof is; how that is indeed the virtue of all virtues, though it be invisible, and as a Nothing in appearance, inasmuch as it is the worker of all things, and a powerful vital energy passing through all virtues and powers natural and supernatural, and the power of all powers, nothing being able to let or obstruct the Omnipotence of Love, or to resist its invincible penetrating might, which passes through the whole Creation of God, inspecting and governing all things.

And in that I said; It is higher than the highest and greater than the greatest; thou mayst hereby perceive as in a glimpse the supreme height and greatness of Omnipotent Love which infinitely transcends all that human sense and reason can reach to. The

highest Archangel and greatest Powers of Heaven, are in comparison of it, but as dwarfs. Nothing can be conceived higher and greater in God himself, by the very highest and greatest of his creatures. There is such infinity in it as comprehends and surpasses all the divine attributes.

But in that it was also said, Its greatness is greater than God; that likewise is very true in the sense wherein it was spoken. For Love can there enter where God dwelleth not, since the most high God dwelleth not in darkness, but in the Light, the hellish darkness being put under his feet. Thus, for instance, when our beloved Lord Jesus Christ was in Hell, Hell was not the mansion of God or of Christ, Hell sees not God, neither was it with God, nor could it be at all with him; Hell stood in the darkness and anxiety of Nature, and no light of the Divine Majesty did there enter; God was not there, for he is not in the darkness nor in the anguish; but Love was there; and Love destroyed Death and conquered Hell. So also when thou art in anguish or trouble, which is hell within, God is not the anguish or trouble, neither is he in the anguish or trouble; but his Love is there, and brings thee out of the anguish and trouble into God, leading thee into the light and joy of his presence. When God hides himself in thee, Love is still there, and makes him manifest in thee. Such is the inconceivable greatness and largeness of Love, which will hence appear to thee as great as God above Nature and greater than God in Nature, or as considered in his manifestative glory.

Lastly, whereas I said, Whosoever finds it finds Nothing and all Things; that is also certain and true. But how finds he Nothing? Why, I will tell thee how. He that findeth it findeth a supernatural, supersensual Abyss, which hath no ground or Byss to stand on, and

where there is no place to dwell in; and he findeth also nothing is like unto it and therefore it may fitly be compared to Nothing, for it is deeper than any Thing, and is as Nothing with respect to All Things, forasmuch as it is not comprehensible by any of them. And because it is Nothing respectively, it is therefore free from All Things, and is that only Good, which a man cannot express or utter what it is, there being Nothing to which it may be compared, to express it by.

But in that I lastly said; Whosoever finds it finds All Things; there is nothing can be more true than this assertion. It hath been the Beginning of All Things; and it ruleth All Things. It is also the End of All Things; and will thence comprehend All Things within its circle. All Things are from it, and in it, and by it. If thou findest it thou comest into that ground from whence All Things are proceeded, and wherein they subsist; and thou art in it a King over all the works of God.

Here the Disciple was exceedingly ravished with what his Master had so wonderfully and surprisingly declared, and returned his most hearty and humble thanks for that light which he had been an instrument of conveying to him. But being desirous to hear further concerning these high matters, and to know somewhat more particularly, he requested him that he would give him leave to wait on him the next day again; and that he would then be pleased to show him how and where he might find this which was so much beyond all price and value, and whereabout the seat and abode of it might be in human nature, with the entire process of the discovery and bringing it forth to light.

The Master said to him: This then we will discourse about at our

next conference, as God shall reveal the same to us by his Spirit, which is a searcher of All Things. And if thou dost remember well what I answered thee in the beginning, thou shalt soon come thereby to understand that hidden mystical wisdom of God; which none of the wise men of the world know; and where the Mine thereof is to be found in thee shall be given thee from above to discern. Be silent therefore in thy spirit, and watch unto prayer; that, when we meet again to-morrow in the love of Christ, thy mind may be disposed for finding that noble Pearl, which to the World appears Nothing, but to the Children of Wisdom is All Things.

DIALOGUE II

The Disciple being very earnest to be more fully instructed how he might arrive at the supersensual life, and how, having found all things, he might come to be a king over all God's works, came again to his Master next morning, having watched the night in prayer, that he might be disposed to receive and apprehend the instructions that should be given him by a divine irradiation upon his mind. And the Disciple, after a little space of silence, bowed himself, and thus brake forth.

Disciple

O my Master, my Master! I have now endeavoured to recollect my soul in the presence of God, and to cast myself into the Deep where no creature doth nor can dwell; that I might hear the voice of my Lord speaking in me, and be initiated into that high life whereof I heard yesterday such great and amazing things. But alas I neither hear nor see as I should. There is still such a partition wall in me which beats back the heavenly sounds in their passage, and obstructs the entrance of that light whereby alone divine objects are discoverable, as till this be gone I can have but small hopes, yea, even none at all, of arriving at those glorious attainments which you pressed me to, or of entering into that where no creature dwells, and which you call Nothing and All Things. Wherefore be so kind as to inform me what is required on my part, that this partition which hinders may be broken or removed.

Master

This partition is the creaturely will in thee, and this can be broken

64

by nothing but the Grace of self-denial, which is the entrance into the true following of Christ, and totally removed by nothing but a perfect conformity with the Divine Will.

Disciple

But how shall I be able to break this creaturely will which is in me, and is at enmity with the Divine Will? Or what shall I do to follow Christ in so difficult a path, and not to faint in a continual course of self-denial or resignation to the Will of God.

Master

This is not to be done by thyself; but by the light and grace of God received into thy soul, which will, if thou gainsay not, break the darkness that is in thee, and melt down thy old will, which worketh in the darkness and corruption of Nature, and bring it into the obedience of Christ, whereby the partition of the creaturely self is removed from betwixt God and thee.

Disciple

I know that I cannot do it of myself. But I would fain learn how I must receive this Divine Light and Grace into me, which is to do it for me, if I hinder it not my own self. What is then required of me in order to admit this Breaker of the partition, and to promote the attainment of the ends of such admission?

Master

There is nothing more required of thee at first than not to resist this

grace, which is manifested in thee; and nothing in the whole process of the work, but to be obedient and passive to the Light of God shining through the darkness of thy creaturely being, which comprehendeth it not, as reaching no higher than the Light of Nature.

Disciple

But is it not for me to attain, if I can, both the Light of God, and the Light of the outward Nature too, and to make use of them both for the ordering of my life wisely and prudently?

Master

It is right so to do. And it is indeed a treasure above all earthly treasures to be possessed of the Light of God and Nature operating in their spheres, and to have both the Eye of Time and Eternity at once open together, and yet not to interfere with each other.

Disciple

This is a great satisfaction to me to hear; having been very uneasy about it for some time. But how this can be without interfering with each other, there is the difficulty. Wherefore fain would I know, if it were lawful, the boundaries of the one and the other, and how both the Divine and the Natural Light may in their several spheres respectively act and operate for the Manifestation of the Mysteries of God and Nature, and for the conduct of my outward and inward life?

Master

That each of these may be preserved distinctly in their several spheres, without confounding Things Heavenly and Things Earthly, or breaking the golden Chain of Wisdom, it will be necessary, my child, in the first place to wait for and attend the Supernatural and Divine Light, as this superior Light appointed to govern the day, rising in the true East, which is the Centre of Paradise, and the great Light breaking forth as out of the darkness within thee, through a pillar of fire and thunder-clouds, and thereby reflecting also upon the inferior Light of Nature a sort of image of itself, whereby only it can be kept in its due subordination; that which is below being made subservient to that which is above, and that which is without to that which is within. Thus there will be no danger of interfering, but all will go right, and everything abide in its proper sphere.

Disciple

Therefore without Reason or the Light of Nature be sanctified in my soul, and illuminated by this superior Light, as from the central East of the holy Light-World, by the Eternal and Intellectual Sun, I perceive there will always be some confusion, and I shall never be able to manage aright either what concerneth Time or Eternity. But I must always be at a loss, or break the links of Wisdom's Chain.

Master

It is even so as thou hast said. All is confusion if thou hast no more than the dim Light of Nature, or unsanctified and unregenerated Reason to guide thee by, and if only the Eye of Time be opened in

thee, which cannot pierce beyond its own limit. Wherefore seek the Fountain of Light, waiting in the deep ground of thy soul for the rising there of the Sun of Righteousness, whereby the Light of Nature in thee, with the properties thereof, will be made to shine seven times brighter than ordinary. For it shall receive the stamp, image and impression of the Supersensual and Supernatural, so that the sensual and rational life will hence be brought into the most perfect order and harmony.

Disciple

But how am I to wait for the rising of this glorious Sun, and how am I to seek in the Centre this Fountain of Light, which may enlighten me throughout and bring my properties into perfect harmony? I am in Nature, as I said before, and which way shall I pass through Nature, and the light thereof, so that I may come into the Supernatural and Supersensual ground whence this true light, which is the Light of Minds, doth arise; and this without the destruction of my nature, or quenching the Light of it, which is my reason?

Master

Cease but from thine own activity, steadfastly fixing thine Eye upon one Point, and with a strong purpose relying upon the promised Grace of God in Christ, to bring thee out of thy Darkness into his marvellous Light. For this end gather in all thy thoughts, and by faith press into the Centre, laying hold upon the Word of God, which is infallible, and which hath called thee. Be thou then obedient to this call, and be silent before the Lord, sitting alone with him in thy inmost and most hidden cell, thy mind being centrally

united in itself, and attending his Will in the patience of hope. So shall thy Light break forth as the Morning, and after the redness thereof is passed, the Sun himself which thou waitest for, shall arise unto thee, and under his most healing wings thou shalt greatly rejoice; ascending and descending in his bright and salutiferous beams. Behold this is the true Supersensual Ground of Life.

Disciple

I believe it indeed to be even so. But will not this destroy Nature? Will not the Light of Nature in me be extinguished by this greater Light? Or, must not the outward Life hence perish, with the earthly body which I carry?

Master

By no means at all. It is true, the evil Nature will be destroyed by it; but by the destruction thereof you can be no loser, but very much a gainer. The Eternal Bond of Nature is the same afterward as before; and the properties are the same. So that Nature hereby is only advanced and meliorated, and the Light thereof, or human Reason, by being kept within its due bounds, and regulated by a superior Light, is only made useful.

Disciple

Pray, therefore, let me know how this inferior Light ought to be used by me; how it is to be kept within its due bounds; and after what manner the superior Light doth regulate it and ennoble it.

Know then, my beloved son, that if thou wilt keep the Light of Nature within its own proper bounds, and make use thereof in just subordination to the Light of God, thou must consider that there are in thy soul two Wills, an inferior Will, which is for driving thee to Things without and below; and a superior Will, which is for drawing thee to Things within and above. These two Wills are now set together, as it were back to back, and in a direct contrariety to each other; but in the beginning it was not so. For this contraposition of the soul in these two is no more than the effect of the Fallen State; since before that they were placed one under the other, that is, the superior Will above, as the Lord, and the inferior below, as the subject. And thus it ought to have continued. Thou must also further consider that, answering to these two Wills, there are likewise two Eyes in the soul, whereby they are severally directed, forasmuch as these Eyes are not united in one single view, but look quite contrary ways at once. They are in a like manner set one against the other, without a common medium to join them. And hence, so long as this double-sightedness doth remain, it is impossible there should be any agreement in the determination of this or that Will. This is very plain. And it showeth the necessity that this malady, arising from the disunion of the rays of vision, be some way remedied and redressed, in order to a true discernment in the mind. Both these eyes therefore must be made to unite by a concentration of rays, there being nothing more dangerous than for the mind to abide thus in the Duplicity and not to seek to arrive at the Unity. Thou perceivest, I know, that thou hast two Wills in thee, one set against the other, the superior and the inferior, and that thou hast always two Eyes within, one against the other, whereof the one Eye may be called the Right Eye, and the other the Left Eye.

Thou perceivest too, doubtless, that it is according to the Right Eye that the wheel of the superior Will is moved; and that it is according to the motion of the Left Eye that the contrary wheel in the lower is turned about.

Disciple

I perceive this, Sir, to be very true; and this it is which causeth a continual combat in me, and createth in me greater anxiety than I am able to express. Nor am I unacquainted with the disease of my own soul, which you have so clearly declared. Alas! I perceive and lament this malady, which so miserably disturbeth my sight; whence I feel such irregular and convulsive motions drawing me on this side and that side. The Spirit seeth not as the Flesh seeth, neither doth, nor can, the Flesh see as the Spirit seeth. Hence the Spirit willeth against the Flesh; and the Flesh willeth against the Spirit in me. This hath been my hard case. And how shall it be remedied? O how may I arrive at the Unity of Will, and how come into the Unity of Vision?

Master

Mark now what I say. The Right Eye looketh forward in thee into Eternity. The Left Eye looketh backward in thee into Time. If thou now sufferest thyself to be always looking into Nature, and the Things of Time, it will be impossible for thee ever to arrive at the Unity, which thou wishest for. Remember this, and be upon thy watch. Give not thy mind leave to enter into nor to fill itself with that which is without thee; neither look thou backward upon thyself; but quit thyself, and look forward to Christ. Let not thy Left Eye deceive thee by making continually one representation after

another, and stirring up thereby an earnest longing in the self-propriety; but let thy right eye command this left, and attract it to thee. Yea it is better to pluck it quite out and to cast it from thee, than to suffer it to proceed forth without restraint into Nature, and to follow its own lusts. However there is for this no necessity, since both eyes may become very useful, if ordered aright, and both the Divine and Natural Light may in the soul subsist together, and be of mutual service to each other. But never shalt thou arrive at the Unity of Vision or Uniformity of Will, but by entering fully into the Will of our Saviour Christ, and therein bringing the Eye of Time into the Eye of Eternity, and then descending by means of these united through the Light of God into the Light of Nature.

Disciple

So then if I can but enter into the Will of my Lord, and abide therein, I am safe, and may both attain to the Light of God in the Spirit of my soul and see with the Eye of God, that is, the Eye of Eternity in the Eternal Ground of my Will; and may also at the same time enjoy the Light of this World nevertheless, not degrading but adorning the Light of Nature, and beholding as with the Eye of Eternity things Eternal, so with the Eye of Nature, things Natural, and both contemplating therein the Wonders of God, and sustaining also thereby the life of my outward vehicle or body.

Master

It is very right. Thou hast well understood, and thou desirest now to enter into the Will of God, and to abide therein as in the Supersensual Ground of Light and Life, where thou mayst in his Light behold both Time and Eternity, and bring all the wonders

72

created of God for the exterior into the interior life, and so eternally rejoice in them to the glory of Christ; the partition of thy Creaturely Will being broken down and the Eye of thy Spirit simplified in and through the Eye of God manifesting itself in the Centre of thy Life. Let this be so now, for it is God's Will.

Disciple

But it is very hard to be always looking forwards into Eternity, and consequently to attain to the single eye, and simplicity of Divine Vision. The entrance of a soul naked into the Will of God, shutting out all imaginations and desires, and breaking down the strong partition which you mention, is indeed somehow very terrible and shocking to human nature in its present state. O what shall I do, that I may reach this which I so much long for?

Master

My Son, let not the Eye of Nature with the Will of the Wonders depart from that Eye which is introverted into the Divine Liberty, and into the Eternal Light of the Holy Majesty. But let it draw to thee by union with that heavenly internal Eye those wonders which are externally wrought out and manifested in visible Nature. For while thou art in the world, and hast an honest employment, thou art certainly by the Order of Providence obliged to labour in it, and to finish the work given thee, according to thy best ability, without repining in the least; seeking out and manifesting for God's glory the Wonders of Nature and Art. Since let the Nature be what it will it is all the Work and Art of God. And let the Art also be what it will, it is still God's Work and his Art, rather than any art or cunning of man. And all both in Art and Nature serveth but

73

abundantly to manifest the wonderful Works of God, that he for all and in all may be glorified. Yea, all serveth, if thou knowest rightly how to use them, only to recollect thee more inwards, and to draw thy Spirit into that majestic Light wherein the original patterns and forms of things visible are to be seen. Keep, therefore, in the Centre, and stir not from the Presence of God revealed within thy Soul; let the world and the devil make never so great a noise and bustle to draw thee out, mind them not; they cannot hurt thee. It is permitted to the Eye of thy Reason to seek food, and to thy hands by their labour to get food for the terrestrial body. But then this Eye ought not with its desire to enter into the food prepared, which would be covetousness; but must in resignation simply bring it before the Eye of God in thy Spirit, and then thou must seek to place it close to this very Eye, without letting it go. Mark this lesson well.

Let the hands or the head be at labour, thy Heart ought nevertheless to rest in God. God is a Spirit; dwell in the Spirit; work in the Spirit; pray in the Spirit; and do every thing in the Spirit; for remember thou also art a Spirit, and thereby created in the Image of God. Therefore see thou attract not in thy desire Matter unto thee, but as much as possible abstract thyself from all Matter whatever; and so, standing in the Centre, present thyself as a naked Spirit before God, in simplicity and purity; and be sure thy Spirit draw in nothing but Spirit.

Thou wilt yet be greatly enticed to draw Matter, and to gather that which the World calls substance; thereby to have somewhat visible to trust to. But by no means consent to the Tempter, nor yield to the lustings of thy Flesh against the Spirit. For in so doing thou wilt infallibly obscure the Divine Light in thee; thy Spirit will stick in the dark Covetous Root, and from the fiery Source of thy soul will it

blaze out in pride and anger; thy Will shall be chained in Earthliness, and shall sink through the Anguish into Darkness and Materiality; and never shalt thou be able to reach the still Liberty, or to stand before the Majesty of God. It will be all darkness to thee, as much Matter as is drawn in by the Desire of thy Will. It will darken God's Majesty to thee, and will close the seeing Eye, by hiding from thee the light of his beloved countenance. This the Serpent longeth to do, but in vain, except thou permittest thy Imagination, upon his suggestion, to receive in the alluring Matter; else he can never get in. Behold then, if thou desirest to see God's Light in thy Soul, and be divinely illuminated and conducted, this is the short way that thou art to take; not to let the Eye of thy Spirit enter into Matter, or fill itself with any Thing whatever, either in Heaven or Earth, but to let it enter by a naked faith into the Light of the Majesty; and so receive by pure love the Light of God, and attract the Divine Power into itself, putting on the Divine Body, and growing up in it to the full maturity of the Humanity of Christ.

Disciple

As I said before, so I say again, this is very hard. I conceive indeed well enough that my Spirit ought to be free from the contagion of Matter, and wholly empty, that it may admit into it the Spirit of God. Also, that this Spirit will not enter, but where the Will entereth into Nothing, and resigneth itself up in the nakedness of faith, and in the purity of love, to its conduct, feeding magically upon the Word of God, and clothing itself thereby with a Divine Substantiality. But, alas, how hard it is for the Will to sink into nothing, to attract nothing, to imagine nothing.

75

Master

Let it be granted that it is so. Is it not surely worth thy while, and all that thou canst ever do?

Disciple

It is so, I must needs confess.

Master

But perhaps it may not be so hard as at first it appeareth to be; make but the trial and be in earnest. What is there required of thee but to stand still and see the salvation of thy God? And couldst thou desire anything less? Where is the hardship in this? Thou hast nothing to care for, nothing to desire in this life, nothing to imagine or attract. Thou needest only cast thy care upon God, who careth for thee, and leave him to dispose of thee according to his good will and pleasure, even as if thou hadst no will at all in thee. For he knoweth what is best; and if thou canst but trust him, he will most certainly do better for thee, than if thou wert left to thine own choice.

Disciple

This I most firmly believe.

Master

If thou believest, then go and do accordingly. All is in the Will, as I have shown thee. When the Will imagineth after Somewhat, then

entereth it into that somewhat, and this somewhat taketh the Will into itself, and overcloudeth it, so as it can have no Light, but must dwell in Darkness, unless it return back out of that somewhat into Nothing. But when the Will imagineth or hasteth after nothing, then it entereth into Nothing, where it receiveth the Will of God into itself, and so dwelleth in Light, and worketh all its works in it.

Disciple

I am now satisfied that the main cause of any one's spiritual blindness, is his letting his Will into Somewhat, or into that which he hath wrought, of what nature soever it be, good or evil, and his setting his heart or affections upon the work of his own hand or brain, and that when the earthly body perisheth, then the Soul must be imprisoned in that very thing which it shall have received and let in; and if the Light of God be not in it, being deprived of the Light of this World, it cannot but be found in a dark prison.

Master

This is a very precious Gate of Knowledge; I am glad thou takest it into such consideration. The understanding of the whole Scripture is contained in it; and all that hath been written from the beginning of the World to this day may be found therein, by him that having entered with his Will into Nothing, hath there found All Things, by finding God, from Whom, and to Whom, and in Whom are All Things. By this means thou shalt come to hear and see God; and after this earthly life is ended to see with the Eye of Eternity all the Wonders of God and of Nature, and more particularly those which shall be wrought by thee in the flesh, or all that the Spirit of God

shall have given thee to labour out for thyself and thy neighbour, or all that the Eye of Reason enlightened from above, may at any time have manifested to thee. Delay not therefore to enter in by this Gate, which if thou seest in the Spirit, as some highly favoured souls have seen it, thou seest in the Supersensual Ground all that God is and can do; thou seest also therewith, as one hath said who was taken thereinto, through Heaven, Hell, and Earth; and through the Essence of all Essences. Whosoever findeth it, hath found all that he can desire. Here is the Virtue and Power of the Love of God displayed. Here is the Height and Depth, here is the Breadth and Length thereof manifested, as ever the capacity of thy soul can contain. By this thou shalt come into that Ground out of which all Things are originated, and in which they subsist; and in it thou shalt reign over all God's Works, as a Prince of God.

Disciple

Pray tell me, dear Master, where dwelleth it in Man?

Master

Where Man dwelleth not: there hath it its seat in Man.

Disciple

Where is that in a Man, when Man dwelleth not in himself?

Master

It is the resigned Ground of a Soul to which nothing cleaveth.

78

Disciple

Where is the Ground in any Soul, to which there will nothing stick?
Or where is that which abideth and dwelleth not in something?

Master

It is the Centre of Rest and Motion in the resigned Will of a truly
contrite Spirit, which is Crucified to the World. This Centre of the
Will is impenetrable consequently to the World, the Devil, and Hell.
Nothing in all the World can enter into it, or adhere to it, because
the Will is dead with Christ unto the World, but quickened with
him in the Centre thereof, after his blessed Image. Here it is where
Man dwelleth not, and where no Self abideth or can abide.

Disciple

O where is this naked Ground of the Soul void of all Self? And how
shall I come at the hidden Centre, where God dwelleth, and not
Man? Tell me plainly, loving Sir, where it is, and how it is to be
found of me, and entered into?

Master

There where the Soul hath slain its own Will, and willeth no more
any Thing as from itself, but only as God willeth, and as his Spirit
moveth upon the Soul shall this appear. Where the Love of Self is
banished there dwelleth the Love of God. For so much of the Soul's
own Will as is dead unto itself even so much room hath the
Will of God, which is his Love, taken up in that Soul. The reason
whereof is this: Where its own Will did before sit, there is now

nothing; and where nothing is, there it is that the Love of God worketh alone.

But how shall I comprehend it?

If thou goest about to comprehend it, then it will fly away from thee; but if thou dost surrender thyself wholly up to it, then it will abide with thee, and become the Life of thy Life, and be natural to thee.

And how can this be without dying, or the whole destruction of my Will?

Upon this entire surrender and yielding up of thy Will, the Love of God in thee becometh the Life of thy Nature; it killeth thee not, but quickeneth thee, who art now dead to thyself in thine own Will, according to its proper Life, even the Life of God. And then thou livest, yet not to thy own Will, but thou livest to its Will; for as much as thy Will is henceforth become its Will. So then it is no longer thy Will, but the Will of God; no longer the Love of thyself, but the Love of God, which moveth and operateth in thee; and then, thou being thus comprehended in it, thou art dead indeed as to thyself, but art alive unto God. So being dead thou livest, or rather God liveth in thee by his Spirit; and his Love is made to thee Life

from the Dead. Never couldst thou with all thy seeking have apprehended it, but it hath apprehended thee. Much less couldst thou have comprehended it, but it hath comprehended thee; and so the Treasure of Treasures is found.

Disciple

How is it that so few Souls do find it, when yet all would be glad enough to have it?

Master

They all seek it in somewhat, and so they find it not. For where there is Somewhat for the Soul to adhere to, there the Soul findeth that somewhat only, and taketh up its rest therein, until she seeth that it is to be found in Nothing, and goeth out of the Somewhat into Nothing, even into that Nothing out of which all Things may be made. The Soul here saith "I have nothing, for I am utterly stripped and naked of every Thing; I can do nothing, for I have no manner of power, but am as water poured out; I am nothing, for all that I am is no more than an Image of Being, and only God is to me I AM; and so, sitting down in my own Nothingness, I give glory to the Eternal Being, and will nothing of myself, that so God may will all in me, being unto me my God and All Things." Herein now it is that so very few find this most precious treasure in the Soul, though every one would so fain have it; and might also have it, were it not for this Somewhat in every one that letteth.

Disciple

But if the Love should proffer itself to a Soul, could not that Soul find it, nor lay hold of it, without going for it into Nothing?

Master

No verily. Men seek and find not, because they seek it not in the naked Ground where it lieth; but in something or other where it never will be, nor can be. They seek it in their own Will, and they find it not. They seek it in their Self-Desire, and they meet not with it. They look for it in an Image, or in an Opinion, or in Affection, or a natural Devotion and Fervour, and they lose the substance by thus hunting after a shadow. They search for it in something sensible or imaginary, in somewhat which they may have a more peculiar natural inclination for, and adhesion to; and so they miss of what they seek, for want of diving into the Supernatural and Supersensual Ground, where the Treasure is hid. Now, should the Love graciously condescend to proffer itself to such as these, and even to present itself evidently before the Eye of their Spirit, yet could it find no place at all in them, neither could it be held by them, or remain with them.

Disciple

Why not, if the Love should be willing and ready to offer itself, and to stay with them?

Master

Because the Imaginariness which is in their own Will hath set itself up in the place thereof. And so this Imaginariness would have the Love in it, but the Love fleeth away, for it is its prison. The Love may offer itself; but it cannot abide where the Self-Desire attracteth or imagineth. That Will which attracteth Nothing, and to which Nothing adhereth, is only capable of receiving it; for it dwelleth only in Nothing, as I said, and therefore they find it not.

Disciple

If it dwell only in Nothing, what is now the office of it in Nothing?

Master

The office of the Love here is to penetrate incessantly into Something; and if it penetrate into, and find a place in Something which is standing still and at rest, then its business is to take possession thereof. And when it hath there taken possession, then it rejoiceth therein with its flaming Love-fire, even as the sun doth in the visible world. And then the office of it is without intermission to enkindle a fire in this Something which may burn it up; and then with the flames thereof exceedingly to enflame itself, and raise the heat of the Love-fire by it, even seven degrees higher.

Disciple

O, loving Master, how shall I understand this?

Master

If it but once kindle a fire within thee, my son, thou shalt then certainly feel how it consumeth all that which it toucheth, thou shalt feel it in the burning up thyself, and swiftly devouring all Egoity or that which thou callest I and Me, as standing in a separate Root, and divided from the Deity, the Fountain of thy Being. And when this enkindling is made in thee, then the Love doth so exceedingly rejoice in thy fire, as thou wouldest not for all the world be out of it; yea, wouldst rather suffer thyself to be killed, than to enter into thy something again. This fire must now grow

hotter and hotter, till it shall have perfected its office with respect to thee. Its flame also will be so very great that it will never leave thee, though it should even cost thee thy temporal life, but it would go with thee with its sweet loving fire into death; and if thou wentest also into Hell, it would break Hell in pieces also for thy sake. Nothing is more certain than this, for it is stronger than Death and Hell.

Disciple

Enough, my dearest Master, I can no longer endure that any Thing should divert me from it. But how shall I find the nearest way to it?

Master

Where the way is hardest, there go thou; and what the World casteth away, that take thou up. What the World doth, that do thou not; but in all things walk thou contrary to the World. So thou comest the nearest way to that which thou art seeking.

Disciple

If I should in all things walk contrary to other people, I must needs be in a very unquiet and sad state, and the World would not fail to account me for a madman.

Master

I bid thee not, Child, to do harm to anyone, thereby to create to thyself any misery or unquietness. This is not what I mean by walking contrary in everything to the World. But because the

84

World, as the World, loveth all deceit and vanity, and walketh in false and treacherous ways, thence, if thou hast a mind to act a clean contrary part to the ways thereof, without any exception or reserve whatsoever, walk thou only in the right way, which is called the Way of Light, as that of the World is properly the Way of Darkness. For the right way, even the Path of Light, is contrary to all the ways of the World.

But whereas thou art afraid of creating to thyself hereby trouble and inquietude, that indeed will be so according to the flesh. In the world thou must have trouble, and thy flesh will not fail to be unquiet, and to give thee occasion of continual repentance. Nevertheless in this very anxiety of soul arising from the world or the flesh, the Love doth most willingly enkindle itself, and its cheering and conquering fire is but made to blaze forth with greater strength for the destruction of that evil. And whereas thou dost also say, that the World will for this esteem thee mad; it is true the World will be apt enough to censure thee for a madman in walking contrary to it, and thou art not to be surprised if the children thereof laugh at thee, calling thee silly Fool. For the Way to the Love of God is Folly to the World, but is Wisdom to the Children of God. Hence, whenever the World perceiveth this holy Fire of Love in God's Children, it concludeth immediately that they are turned fools, and are beside themselves. But to the Children of God that which is despised of the World is the greatest Treasure, yea, so great a Treasure is it as no life can express, nor tongue so much as name what this enflaming, all-conquering Love of God is. It is brighter than the Sun; it is sweeter than anything that is called sweet; it is stronger than all strength; it is more nutrimental than food; more cheering to the heart than wine, and more pleasant than all the joy and pleasantness of this world. Whosoever obtaineth it is

85

richer than any Monarch on earth; and he who getteth it, is nobler than any Emperor can be, and more potent and absolute than all Power and Authority.

DIALOGUE III

BETWEEN JUNIUS, A SCHOLAR, AND THEOPHORUS, HIS MASTER, CONCERNING HEAVEN AND HELL

The Scholar asked his Master "Whither goeth the Soul when the Body dieth?"

His Master answered him: There is no necessity for it to go any whither.

How not, said the inquisitive Junius, must not the Soul leave the body at death and go either to Heaven or Hell?

It needs no going forth, replied the venerable Theophorus. Only the outward Mortal Life with the body shall separate themselves from the Soul. The Soul hath Heaven and Hell within itself before, according as it is written. The Kingdom of God cometh not with observation, neither shall they say Lo here! or Lo there! For behold the Kingdom of God is within you. And which soever of the two, that is, either Heaven or Hell, is manifested in it, in that the Soul standeth.

Here Junius said to his Master: This is hard to understand. Doth it not enter into Heaven or Hell, as a man entereth into a house; or as one goeth through a hole or casement into an unknown place; so goeth it not into another world?

The Master spoke and said: No, there is verily no such kind of entering in; forasmuch as Heaven and Hell are every where, being universally co-extended.

How is that possible? said the Scholar. What, can Heaven and Hell be here present, where we are now sitting? And if one of them might, can you ever make me believe that ever both should be here together?

Then spoke the Master in this manner: I have said that Heaven is everywhere present and it is true. For God is in Heaven; and God is everywhere. I have said also that Hell must be in like manner everywhere. For the Wicked One, who is the Devil, is in Hell, and the whole World, as the Apostle hath taught us, lyeth in the Wicked One, or the Evil One; which is as much as to say, not only that the Devil is in the World, but that the World is in the Devil; and if in the Devil, then in Hell too, because he is there. So Hell therefore is everywhere, as well as Heaven; which is the thing that was to be proved.

The Scholar, startled hereat, said: Pray make me to understand this.

To whom the Master: Understand then what Heaven is. It is but the turning in of the Will to the Love of God. Wheresoever thou findest God manifesting himself in Love, there thou findest Heaven, without travelling for it so much as one foot. And by this understand also what Hell is and where it is. I say unto thee it is but the turning in of the Will into the wrath of God. Wheresoever the Anger of God doth more or less manifest itself, there certainly is more or less of Hell, in whatsoever place it be. So that it is but the turning in of thy will either into his Love, or into his Anger; and thou art accordingly either in Heaven or in Hell. Mark it well. And this now cometh to pass in this present life, whereof St Paul speaking saith, Our conversation is in Heaven. And the Lord Christ saith also, My sheep hear my voice, and I know them, and they

follow me, and I give them the Eternal Life, and none shall pluck them out of my hand. Observe, he saith not, I will give them, after this life is ended, but I give them, that is, now in the time of this life. And what else is this gift of Christ to his followers, but an Eternity of Life, which for certain can be no where but in Heaven. Yea, moreover, none shall be able to pluck them out of Heaven, because it is he who holdeth them there, and they are in his hand which nothing can resist. All therefore doth consist in the turning in, or entering of the Will into Heaven, by hearing the the voice of Christ, and both knowing him, and following him. And so on the contrary it is also. Understandest thou this?

His Scholar said to him: I think, in part, I do. But how cometh this entering of the Will into Heaven to pass?

The Master answered him: This then will I endeavour to satisfy thee in; but thou must be very attentive to what I shall say unto thee. Know then, my son, that when the Ground of the Will yieldeth itself up to God, then it sinketh out of its own Self, and out of and beyond all ground and place, that is or can be imagined, into a certain unknown Deep, where God only is manifest, and where he only worketh and willeth. And then it becometh nothing to itself, as to its own working and willing, and so God worketh and willeth in it. And God dwells in this designed Will, by which the Soul is sanctified, and so fitted to come into Divine Rest. Now, in this case, when the body breaketh, the Soul is so thoroughly penetrated all over with the Divine Light, even as a glowing hot iron is by the fire, by which being penetrated throughout, it loseth its darkness, and becomes bright and shining. Now this is the hand of Christ, where God's Love thoroughly inhabits the Soul, and is in it a shining Light, and a new glorious Life. And then the Soul is in Heaven, and

is a Temple of the Holy Ghost, and is itself the very Heaven of God, wherein he dwelleth. Lo, this is the entering of the Will into Heaven; and thus it cometh to pass.

Be pleased, Sir, to proceed, said the Scholar, and let me know how it fareth on the other side.

The Master said: The godly Soul, you see, is in the hand of Christ, that is in Heaven, as he himself hath told us, and in what manner this cometh to be so, you have also heard. But the ungodly Soul is not willing in this life-time to come into the Divine Resignation of its Will, or to enter into the Will of God; but goeth on still in its own lust and desire, in vanity and falsehood, and so entereth into the Will of the Devil. It receiveth, thereupon, into itself nothing but wickedness; nothing but lying, pride, covetousness, envy and wrath; and thereunto it giveth up its Will and whole Desire. This is the Vanity of the Will; and this same Vanity or vain shadow must also in like manner be manifested in the Soul, which hath yielded itself up also to be its servant; and must work therein even as the Love of God worketh in the regenerated Will; and penetrate it all over, as fire doth iron.

And it is not possible for this Soul to come into the Rest of God, because God's Anger is manifested in it, and worketh in it. Now when a body is parted from the Soul, then beginneth the Eternal Melancholy and Despair, because it now findeth that it is become altogether Vanity, even a Vanity most vexatious to itself, and a distracting Fury, and a self-tormenting Abomination. Now it perceiveth itself disappointed of every Thing which it had before fancied, and blind, and naked, and wounded, and hungry, and thirsty, without the least prospect of ever being relieved, or

obtaining so much as one drop of the water of Eternal Life. And it feeleth itself to be its own vile executioner and tormentor; and is affrighted at its own ugly dark form, and fain would flee from itself if it could, but it cannot, being fast bound with the chains of the Dark Nature, whereinto it had sunk itself when in the flesh. And so, not having learned or accustomed itself to sink down into the Divine Grace, and being also strongly possessed with the Idea of God, as an angry and jealous God, the poor Soul is both afraid and ashamed to bring its Will into God, by which deliverance might possibly come to it. The Soul is afraid to do it, as fearing to be consumed by so doing, under the apprehension of the Deity as a mere devouring Fire. The Soul is also ashamed to do it, as being confounded at its own nakedness and monstrosity, and therefore would, if it were possible, hide itself from the Majesty of God, and cover its abominable form from his most holy eye, though by casting itself still deeper into the Darkness. Therefore it will not enter into God, nay, it cannot enter with its false Will; yea, though it should strive to enter, yet can it not enter into the Love, because of the Will which hath reigned in it. For such a Soul is thereby captivated in the Wrath, yea, is itself but mere Wrath, having by its false Desire, which it had awakened in itself, comprehended and shut itself up therewith, and so transformed itself into the nature and property thereof.

And since also the Light of God doth not shine in it, nor the Love of God enclose it, the Soul is moreover a great Darkness, and is withal an anxious Fire-source, carrying about an Hell in itself, and not being able to discern the least glimpse of the Light of God, or to feel the least spark of his Love. Thus it dwelleth in itself as in Hell, and needeth no entering into Hell at all, or being carried thither, for in what place soever it may be, so long as it is in itself, it is in the Hell.

And though it should travel far and cast itself many hundred thousand leagues from its present place, to be out of Hell; yet still would it remain in its hellish source and darkness.

If this be so, how then cometh it, said the Scholar to Theophorus, that an Heavenly Soul doth not in the time of this life perfectly perceive the Heavenly Light and Joy, and the Soul which is without God in the World, doth not also here feel Hell, as well as hereafter? Why should they not both be perceived and felt as well in this life as in the next, seeing that both of them are in Man, and one of them as you have shewed, worketh in every man?

To whom Theophorus presently returned this answer: The Kingdom of Heaven is in the Saints operative and manifestative of itself by Faith. They who carry God within them, and live by his Spirit, find the Kingdom of God in their Faith, and they feel the Love of God in their Faith, by which the Will hath given up itself unto God, and is made Godlike. All is transacted within them by Faith, which is to them the evidence of the Eternal Invisibles, and a great manifestation in their Spirit of this Divine Kingdom, which is within them. But their natural life is nevertheless encompassed with flesh and blood; and this standing in a contrariety thereto, and being placed through the Fall in the principle of God's Anger, and environed about with the World, which by no means can be reconciled to Faith, these faithful Souls cannot but be very much exposed to attacks from this World, wherein they are sojourners; neither can they be insensible of their being thus encompassed about with flesh and blood, and with the World's vain lust, which ceaseth not continually to penetrate the outward mortal life, and to tempt them manifold ways, even as it did Christ. Whence the World on one side and the Devil on the other, not without the curse

92

of God's Anger in flesh and blood, do thoroughly sift and penetrate the Life, whereby it cometh to pass that the Soul is often in anxiety when these three are all set upon it together, and when Hell thus assaulteth the Life, and would manifest itself in the Soul. But the Soul hereupon sinketh down into the hope of the Grace of God, and standeth like a beautiful Rose in the midst of Thorns, until the Kingdom of this World shall fall from it in the death of the body. And then the Soul first becometh truly manifest in the Love of God, and of his Kingdom, which is the Kingdom of Love; having henceforth nothing more to hinder it. But during this life she must walk with Christ in this world, and then Christ delivereth her out of her own Hell, by penetrating her with his Love throughout, and standing by her in Hell, and even changing her Hell into Heaven.

But in that thou sayest, Why do not the Souls which are without God feel Hell in this World? I answer; They bear it about with them in their wicked consciences, but they know it not; because the World hath put out their eyes, and its deadly cup hath cast them likewise into a sleep, a most fatal sleep. Notwithstanding which it must be owned that the Wicked do frequently feel Hell within them during the time of this mortal life, though they may not apprehend that it is Hell, because of the earthly vanity which cleaveth to them from without, and the sensible pleasures and amusements wherewith they are intoxicated. And moreover it is to be noted that the outward Life in every such one hath yet the Light of the outward Nature, which ruleth in this Life, and so the Pain of Hell cannot, so long as that hath the rule, be revealed. But when the body dyeth or breaketh away, so as the Soul cannot any longer enjoy such temporal pleasure and delight, nor the Light of this outward World, which is wholly thereupon extinguished as to it, then the Soul stands in an eternal hunger and thirst after such

vanities as it was here in love withal, but yet can reach nothing but that false Will, which it had impressed in itself while in the body; and wherein it had abounded to its great loss. And now whereas it had too much of its Will in this life, and yet was not contented therewith, it hath, after the separation by death, as little of it; which createth in it an everlasting thirst after that which it can henceforth never obtain more, and causeth it to be in a perpetual anxious lust after Vanity, according to its former impression, and in a continual rage of hunger after those sorts of wickedness and lewdness whereinto it was immersed, being in the flesh. Fain would it do more evil still, but that it hath not either wherein or wherewith to effect the same, and therefore it doth perform this only in itself. All is not literally transacted, as if it were outward; and so the ungodly is tormented by those Furies which are in his own mind, and begotten upon himself by himself. For he is verily become his own Devil and Tormentor; and that by which he sinned here, when the Shadow of this World is passed away, abideth still with him in the impression, and is made his prison and his Hell. But this hellish hunger and thirst cannot be fully manifested in the Soul, till the Body, which ministered to the Soul that it lusted after, and with which the Soul was so bewitched, as to doat thereupon, and pursue all its cravings, be stripped off from it.

I perceive then, said Junius to his Master, that the Soul, having played the wanton with the Body in all voluptuousness, and served the lusts thereof during this life, retaineth still the very same inclinations and affections which it had before, then when it hath no opportunity or capacity to satisfy them longer; and that when this cannot be, there is then Hell opened in that Soul, which had been shut up in it before by means of the outward Life in the Body, and of the Light of this World. Do I rightly understand?

Theophorus said: It is very rightly understood by you. Go on.

On the other hand (said he) I clearly perceive by what I have heard, that Heaven cannot but be in a loving Soul which is possessed of God, and hath subdued thereby the Body to the obedience of the Spirit in all things, and perfectly immersed itself into the Will and Love of God. And when the Body dyeth, and the Soul is hence redeemed from the Earth, it is now evident to me that the Life of God, which was hidden in it, will display itself gloriously, and Heaven consequently be then manifested. But, notwithstanding, if there be not a local Heaven besides and a local Hell, I am still at a loss where to place no small part of the Creation, if not the greatest. For where must all the intellectual inhabitants of it abide?

In their own Principle, answered the Master, whether it be of Light or of Darkness. For every created intellectual Being remaineth in its deeds and essences, in its wonders and properties, in its life and image; and therein it beholdeth and feeleth God, as who is everywhere, whether it be in the Love or in the Wrath.

If it be in the Love of God, then beholdeth it God accordingly, and feeleth him as he is, Love. But if it hath captivated itself in the Wrath of God, then it cannot behold God otherwise than in the Wrathful Nature, nor perceive him otherwise than as an incensed and vindictive Spirit. All places are alike to it, if it be in God's Love; and, if it be not there, every place is Hell alike. What Place can bound a Thought? Or what needeth any understanding Spirit to be kept here or there, in order to its happiness or misery? Verily, wheresoever it is, it is in the Abyssal World, where there is neither end nor limit. And whither, I pray, should it go? since though it should go a thousand miles off, or a thousand times ten thousand

miles, and this ten thousand times over beyond the bounds of the Universe, and into the imagining spaces above the stars, yet it were then still in the very same point from whence it went out. For God is the Place of Spirit, if it may be lawful to attribute to him such a name to the which Body hath a relation. And in God there is no limit; both near and far off is here all one; and be it in his Love, or be it in his Anger, the abyssal Will of the Spirit is altogether unconfined. It is swift as thought, passing through all things; it is magical, and nothing corporeal or from without can let it; it dwelleth in its wonders, and they are its house.

Thus it is with every Intellectual, whether of the Order of Angels or of human Souls, and you need not fear but there will be room enough for them all, be they ever so many; and such also as shall best suit them, even according to their election and determination, and which may thence very well be called the "own place" of each.

At which said the Scholar, I remember, indeed, that it is written concerning the great traitor, that he went after death to his own place.

The Master said: The same is true of every Soul, when it departeth this mortal life. And it is true in like manner of every Angel and Spirit whatsoever, which is necessarily determined by its own choice. As God is everywhere, so also the Angels are everywhere; but each one in its own Principle, and in its own Property or (if you had rather) in its own Place. The same Essence of God, which is as a Place to Spirits, is confessed to be everywhere, but the appropriation or participation hereof is different to everyone, according as each hath attracted it magically in the earnestness of Will. The same Divine Essence which is with the Angels of God

96

above, is with us also below. And the same Divine Nature which is with us is likewise with them; but after different manners and in different degrees communicated and participated.

And what I have said here of the Divine, is no less to be considered by you in the participation of the Diabolical Essence and Nature, which is the Power of Darkness, as to the manifold modes, degrees, and appropriations thereof in the false Will. In this World there is strife between them, but when this World hath reached in anyone the Limit, then the Principle catcheth that which is its own, and so the Soul receiveth companions accordingly, that is, either Angels or Devils.

To whom the Scholar again: Heaven and Hell then being in us at strife in the time of this life, and God himself being also thus near to us, where can Angels and Devils dwell?

And the Master answered him thus: Where thou dost not dwell as to thy Self-hood and to thine own Will, there the holy Angels dwell with thee, and every where all over round about thee. Remember this well. On the contrary, where thou dwellest as to thyself, or in Self-seeking, and Self-will, there to be sure the Devils will be with thee, and will take up their abode with thee, and dwell all over thee, and round about thee everywhere, which God in his mercy prevent.

I understand not this, said the Scholar, so perfectly well as I could wish. Be pleased to make it a little more plain to me.

The Master then spake: Mark well what I am going to say. Where the Will of God in anything willeth, there is God manifested. And

in this very manifestation of God the Angels do dwell. But where God in any Creature willeth not with the Will of that Creature, there God is not manifested to it, neither can he be; but dwelleth in himself, without the co-operation thereof, and subjection to him in humility. There God is an unmanifested God to the Creature. So the Angels dwell not with such an one; for wherever they dwell, there is the Glory of God; and they make his Glory. What then dwelleth in such a Creature as this? God dwelleth not therein; the Angels dwell not therein; God willeth not therein; the Angels also will not therein. The case is evidently this; in that Soul or Creature its own will is without God's Will; and there the Devil dwelleth; and with him all that is without God, and without Christ. This is the truth; lay it to heart.

The Scholar said: It is possible I may ask several impertinent questions; but I beseech you, good Sir, to have patience with me, and to pity my ignorance, if I ask what may appear to you perhaps ridiculous, or may not be at all fit for me to expect an answer to. For I have several questions still to propound to you; but I am ashamed of my own thoughts in this matter.

The Master said: Be plain with me, and propose whatever is upon your mind; yea, be not ashamed even to appear ridiculous, so that by querying you may but become wiser.

The Scholar thanked his Master for this liberty and said: How far then are Heaven and Hell asunder?

To whom he answered thus: As far as Day and Night; or as far as Something and Nothing. They are in one another and yet they are at the greater distance one from the other. Nay, the one of them is

98

as nothing to the other; and yet notwithstanding they cause joy and grief to one another. Heaven is throughout the whole World, and it is also without the World over all, even everywhere that is, or that can be even so much as imagined. It filleth all, it is within all, it is without all, it encompasseth all; without division, without place; working by a Divine Manifestation, and flowing forth universally, but not going in the least out of itself. For only in itself it worketh and is revealed, being one and undivided in all. It appeareth only through the Manifestation of God; and never but in itself only. And in that Being which cometh into it, or in that wherein it is manifested; there also it is that God is manifested. Because Heaven is nothing else but a Manifestation or Revelation of the Eternal One, wherein all the working and willing is in quiet love.

So in like manner Hell also is through the whole World, and dwelleth and worketh but in itself, and in that wherein the Foundation of Hell is manifested, namely, in Self-hood and in the False Will. The visible World hath both in it; and there is no place but Heaven and Hell may be found or revealed in it. Now Man as to his temporal life is only of the visible World; and therefore during the time of his life he seeth not the spiritual World. For the Outward World with its substance is a cover to the Spiritual World, even as the Body is to the Soul. But when the outward Man dyeth, then the Spiritual World is manifested to the Soul, which hath now its covering taken away. And it is manifested either in the Eternal Light with the holy Angels, or in the Eternal Darkness, with the Devils.

The Scholar further queried: What is an Angel, or an human Soul, that they can be thus manifested either in God's Love or Anger, either in Light or Darkness?

To whom Theophorus answered: They come from one and the self-same Original. They are little branches of the Divine Wisdom, of the Divine Will, sprung from the Divine Word, and made objects of the Divine Love. They are out of the Ground of Eternity; whence Light and Darkness do spring; Darkness which consisteth in the receiving of Self-Desire; and Light which consisteth in willing the same thing with God. For the conformity of the Will with God's Will is Heaven; and wheresoever there is this willing with God, there the Love of God is undoubtedly in the working, and his Light will not fail to manifest itself. But in the Self-attraction of the Soul's desire, or in the reception of Self into the willing of any Spirit, angelical or human, the Will of God worketh with difficulty, and is to that Soul and Spirit nought but Darkness; out of which, notwithstanding, the Light may be manifested. And this Darkness is the Hell of that Spirit wherein it is. For Heaven and Hell are nought else but a Manifestation of the Divine Will either in Light or Darkness, according to the Properties of the Spiritual World.

Scholar

What then is the Body of Man?

Master

It is the visible World, an Image and Quintessence, or Compound of all that the World is; and the visible World is a manifestation of the inward spiritual World, come out of the Eternal Light, and out of the Eternal Darkness, out of the spiritual compaction or connection; and it is also an Image or Figure of Eternity, whereby Eternity hath made itself visible; where Self-Will and resigned Will, viz., Evil and Good, work one with the other.

Such a substance is the outward Man. For God created Man out of the outward World, and breathed into him the inward spiritual World for a Soul and an intelligent Life, and therefore in the things of the outward World, Man can receive and work Evil and Good.

Scholar

What shall be after this World, when all things perish and come to an end?

Master

The material substance only ceaseth; viz., the four Elements, the Sun, Moon and Stars. And then the inward world will be wholly visible and manifest. But whatsoever hath been wrought by the Will or Spirit of Man in this World's time, whether evil or good shall there separate itself in a spiritual matter, either into the Eternal Light or into the Eternal Darkness. For that which is born from each Will penetrateth and passeth again into that which is like itself. And there the Darkness is called Hell, and is an eternal forgetting of all Good, and the Light is called the Kingdom of God, and is an eternal joy in and to the Saints, who continually glorify and praise God, for having delivered them from the torment of evil.

The last Judgment is a kindling of the Fire both of God's Love and Anger, in which the matter of every substance perisheth, and each Fire shall attract into itself its own, that is, the substance which is like itself. Thus God's Fire of Love will draw into itself what is wrought in the Anger of God in Darkness, and consume the false substance; and then there will remain only the painful, aching Will in its own proper nature, image, and figure.

Scholar

With what matter and form shall the human Body rise?

Master

It is sown a natural gross and elementary Body; yet in this gross
Body there is a subtle Power and Virtue. As in the Earth also there
is a subtle good Virtue, which is like the Sun, and is one and the
same with the Sun, which also did in the beginning of time spring
and proceed out of the Divine Power and Virtue, whence all the
good Virtue of the Body is likewise derived. This good Virtue of the
mortal Body shall come again and live for ever in a kind of
transparent crystalline material property, in spiritual flesh and
blood; as shall return also the good Virtue of the Earth, for the
Earth, likewise shall become crystalline, and the Divine Light shine
in everything that hath a being, essence, or substance. And as the
gross Earth shall perish and never return, so also the gross flesh of
Man shall perish and not live for ever. But all Things must appear
before the Judgment, and in the Judgment be separated by the Fire;
yea, both the Earth, and also the ashes of the human Body. For
when God shall once move the spiritual World, every Spirit shall
attract its spiritual substance to itself. A good Spirit and Soul
shall draw to itself its own substance, and an evil one its evil
substance.

Scholar

Shall we not rise again with our visible bodies, and live in them for
ever?

Master

When the visible world perisheth, then all that hath come out of it, and hath been external, shall perish with it. There shall remain of the World only the crystalline Nature and Form, and of Man also only the spiritual Earth, for Man shall be then wholly like the crystalline World, which as yet is hidden.

Scholar

Shall all then have eternal joy and glorification alike?

Master

St Paul saith: In the Resurrection one shall differ from another in glory, as do the Sun, Moon and Stars. Therefore know that the Blessed shall indeed all enjoy the divine working in and upon them, but their virtue and illumination or glory shall be very different according as they have endured in this life with different measures and degrees of power and virtue in their painful workings.

Scholar

How shall all people and nations be brought to judgment?

Master

The Eternal Word of God, out of which every creaturely spiritual Life hath proceeded will move itself at that hour, according to Love and Anger, in every Life which is come out of the Eternity, and will draw every Creature before the Judgment of Christ, to be sentenced by this motion of the Word. The Life will then be manifested in all

its works, and every Soul shall see and feel its judgment and sentence in itself. For the Judgment is, indeed, immediately at the departure of the Body manifested in and to every Soul. And the last Judgment is but a return of the spiritual Body, and a separation of the World, when the Evil shall be separated from the Good, in the substance of the World, and of the human Body, and everything enter into its eternal receptacle. And thus it is a manifestation of the Mystery of God in every substance and life.

Scholar

How will the sentence be pronounced?

Master

Here consider the words of Christ. He will say to those on his right hand; Come, ye blessed of my Father, inherit the kingdom prepared for you from the foundation of the world. For I was hungry and ye gave me meat; I was thirsty and ye gave me drink; I was a stranger and ye took me in; naked and ye clothed me. I was sick and ye visited me, in prison and ye came unto me.

Then shall they answer him, saying, Lord, when saw we thee hungry, thirsty, a stranger, naked, sick, or in prison, and ministered thus unto thee?

Then shall the King answer and say unto them; Inasmuch as ye have done it unto one of the least of these my brethren, ye have done it unto me.

And unto the wicked on his left hand he will say; Depart from me, ye Cursed, into everlasting fire, prepared for the Devil and his

Angels. For I was hungry, thirsty, a stranger, naked, and in prison, and ye ministered not unto me.

And they shall also answer him and say; When did we see thee thus and ministered not unto thee?

And he will answer them, Verily I say unto you, inasmuch as ye have not done it unto one of the least of these, ye did it not to me.

And these shall depart into everlasting punishment, but the Righteous into Life Eternal.

Scholar

Loving Master, pray tell me why Christ saith, What you have done to the least of these you have done to me; and what you have not done to them, neither have you done it to me? And how doth a Man this so, as that he doth it to Christ himself?

Master

Christ dwelleth really and essentially in the faith of those that wholly yield up themselves to him, and giveth them his Flesh for food and his Blood for drink; and thus possesseth the ground of their faith, according to the interior or inward Man. And a Christian is called a Branch of the Vine Christ, and a Christian, because Christ dwelleth spiritually in him; therefore, whatsoever good any shall do to such a Christian in his bodily necessities, it is done to Christ himself, who dwelleth in him. For such a Christian is not his own, but is wholly resigned to Christ, and become his peculiar possession, and consequently the good deed is done to Christ

himself. Therefore also whosoever shall withhold their help from such a needy Christian, and forbear to serve him in his necessity, they thrust Christ away from themselves, and despise him in his members. When a poor person that belongeth thus to Christ asketh anything of thee, and thou deniest it him in his necessity, thou deniest it to Christ himself. And whatsoever hurt any shall do to such a Christian, they do it to Christ himself. When any mock, scorn, revile, reject, or thrust away such an one they do all that to Christ, but he that receiveth him, giveth him meat, and drink, or apparel, and assisteth him in his necessities, doth it likewise to Christ, and to a fellow-member of his own Body. Nay he doth it to himself if it be a Christian; for we are all one in Christ, as a tree and its branches are.

Scholar

How then will those subsist in the day of the last Judgment, who afflict and vex the poor and distressed, and deprive them of their very sweat, necessitating and constraining them by force to submit to their wills, and trampling upon them as their footstools, only that they themselves may live in pomp and power, and spend the fruits of this poor people's sweat and labour in voluptuousness, pride, and vanity?

Master

Christ suffereth in the persecution of his members. Therefore all the wrong that such hard executors do to the poor wretches under their control is done to Christ himself; and falleth under his severe sentence and judgment. And besides that by such oppression of the Poor they draw them off from Christ, and make them seek unlawful

ways to fill their bellies. Nay, they work for and with the Devil himself, doing the very same thing which he doth: who, without intermission opposeth the Kingdom of Christ, which consisteth only in Love. All these oppressors, if they do not turn with their whole hearts unto Christ, and minister to or serve him, must go into Hell-fire, which is fed and kept alive by nothing else but such mere Self, which they have exercised over the Poor here.

Scholar

But how will it fare with those who in this time do so fiercely contend about the kingdom of Christ, and slander, revile and persecute one another for their religion?

Master

All such have not yet known Christ; and they are but as a type or figure of Heaven and Hell, striving for each other for the victory.

All rising, swelling pride, which contendeth about opinions, is an image of Self. And whosoever hath not faith and humility, nor liveth in the Spirit of Christ, which is Love, is only armed with the Anger of God, and helpeth forward the victory of the imaginary Self, that is, the Kingdom of Darkness, and the Anger of God. For at the day of Judgment all Self shall be given to the Darkness as shall also all the unprofitable contentions of men; in which they seek not after Love, but merely after their imaginary Self. All such things belong to the Judgment, which will separate the false from the true; and then all images or opinions shall cease, and all the Children of God shall dwell for ever in the Love of Christ, and that in them. For in Heaven all serve God their Creator in humble love.

Scholar

Wherefore then doth God suffer such strife and contention to be in this time?

Master

The Life itself standeth in strife, that it may be made manifest, sensible, and palpable, and that the wisdom may be made separable and known.

The Strife also constituteth the Eternal Joy of the victory. For there will arise great praise and thanksgiving in the Saints from the experimental sense and knowledge that Christ in them hath overcome Darkness, and all the Self of Nature, and that they are at length totally delivered from the Strife, at which they shall rejoice eternally. And therefore God suffereth all Souls to stand in a free-will, that the Eternal Dominion both of Love and Anger, of Light and of Darkness, may be made manifest and known; and that every Life might cause and find its own sentence in itself. For that which is now a strife and pain to the Saints in their wretched warfare here, shall in the end be turned into great joy to them; and that which hath been a joy and pleasure to ungodly persons in this world, shall afterwards be turned into eternal torment and shame to them. Therefore the joy of the Saints must arise to them out of death, as the light ariseth out of a candle by the destruction and consumption of it in its fire, that so the Life may be freed from the painfulness of Nature, and possess another World.

And as the Light hath quite another property than the Fire has, for it giveth and yieldeth itself forth; whereas the Fire draweth in and

consumeth itself, so the holy Life of Meekness springeth forth through the Death of Self-will, and then God's Will of Love only ruleth, and doth all in all. For thus the Eternal One hath attained Feeling and Separability, and brought itself forth again with the feeling, through Death, in great Joyfulness, that there might be an Eternal Delight in the Infinite Unity, and an Eternal Cause of Joy; and therefore that which was before Painfulness, must now be the Ground and Cause of this motion or stirring to the Manifestation of all Things. And herein lyeth the Mystery of the hidden Wisdom of God.

Every one that asketh receiveth, every one that seeketh findeth, and to every one that knocketh it shall be opened. The Grace of our Lord Jesus Christ, and the Love of God, and the Communion of the Holy Ghost, be with us all. Amen.

DIALOGUE IV

THE WAY FROM DARKNESS TO TRUE ILLUMINATION

There was a poor Soul that had wandered out of Paradise, and come into the kingdom of this World; where the Devil met it, and said to it: Whither dost thou go, thou Soul that art half blind?

The Soul said

I would see and speculate into the Creatures of the World, which their Creator hath made.

The Devil said

How wilt thou see and speculate into them, when thou canst not know their essence and property? Thou wilt look upon their outside only, as upon a graven image, and canst not know them thoroughly.

The Soul said

How may I come to know their essence and property?

The Devil said

Thine eyes would be opened to see them thoroughly, if thou didst but eat of that, from whence the Creatures themselves are come to be good and evil. Thou wouldst then be as God himself is, and know what the Creature is.

The Soul said

I am now a noble and holy Creature: but if I should do so, the Creator hath said that I should die.

The Devil said

No, thou shouldst not die at all; but thy eyes would be opened, and thou wouldst be as God himself, and be Master of Good and Evil. Also, thou wouldst be mighty, powerful and very great, as I am; all the subtlety that is in the Creatures would be made known to thee.

The Soul said

If I had the knowledge of Nature and of the Creatures, I would then rule the whole World as I listed.

The Devil said

The whole ground of their knowledge lieth in thee. Do but turn thy Will and Desire from God or Goodness into Nature and the Creatures, and then there will arise in thee a lust to taste; and so thou mayest eat of the Tree of Knowledge of Good and Evil, and by that means come to know all things.

The Soul said

Well then, I will eat of the Tree of Knowledge of Good and Evil, that I may rule all things by my own power, and be of myself a Lord on Earth, and do what I will, even as God himself doth.

The Devil said

I am the Prince of this World; and if thou wouldst rule on earth thou must turn thy lust towards my Image, and desire to be like me, that thou mayst get the cunning, wit, reason, and subtlety that my Image hath.

Thus did the Devil present to the Soul the Power that is in the fiery root of the Creature, that is the fiery Wheel of Essence in the form of a Serpent. Upon which,

The Soul said

Behold this is the Power which can do all things. What must I do to get it?

The Devil said

If thou dost break thy Will off from God, and bring it into this power and skill, then thy hidden Ground will be manifested in thee, and thou mayest work in the same manner. But thou must eat of that Fruit, wherein each of the four elements in itself ruleth over the other, and is in strife. And then thou wilt be instantly as the fiery Wheel is, and so bring all things into thine own power, and possess them as thine own.

The Soul did so and what happened thereupon

Now when the Soul broke its will off thus from God, and brought it into the fiery Will (which is the Root of Life and Power), there

presently arose in it a lust to eat of the Tree of Knowledge of Good and Evil; and the Soul did eat thereof. Which as soon as it had done, instantly was kindled the fiery Wheel of its Essence, and thereupon all the properties of Nature awoke in the Soul, and exercised each its own desire.

First arose the lust of Pride; a desire to be great, mighty, and powerful; to bring all things in subjection to it, and to be Lord itself without control, despising all humility and equality, as esteeming itself the only prudent, witty and cunning one, and accounting everything folly that is not according to its own humour and liking.

Secondly, arose the lust of Covetousness, a desire of getting, which would draw all things to itself, into its own possession. For when the lust of Pride had turned away the Will from God, then the Life of the Soul would not trust God any further, but would take care for itself; and therefore brought its desire into the Creatures, viz., into the earth, metals, trees, and other Creatures. Thus the kindled fiery Life became hungry and covetous, when it had broken itself off from the Unity, Love, and Meekness of God, and attracted to itself the four Elements and New Essence, and brought itself into the Condition of the beasts, and so the Life became dark, empty, and wrathful; and the heavenly Virtues and Colours went out, like a candle extinguished.

Thirdly, there awoke in this fiery Life the stinging thorny lust of Envy: a hellish poison, and a torment which makes the Life a mere enmity to God and to all Creatures. Which Envy raged furiously in the sting of Covetousness, as a venomous sting doth in the body. Envy cannot endure, but hateth and would hurt or destroy that

113

which Covetousness cannot draw to itself by which hellish passion the Noble Love of the Soul is smothered.

Fourthly, there awoke in this fiery Life a torment like fire, viz., Anger; which would murder and remove out of the way all who would not be subject to Pride. Thus the Ground and Foundation of Hell, which is called the Anger of God, was wholly manifested in this Soul. Whereby it lost the fair Paradise of God and the Kingdom of Heaven, and became such a worm as the fiery Serpent was, which the Devil presented to it in his own image and likeness. And so the Soul began to rule on earth in a bestial manner, and did all things according to the Will of the Devil, living in mere Pride, Covetousness, Envy, and Anger, having no longer any true love towards God. But there arose in the stead thereof an evil bestial love of Wantonness and Vanity, and there was no purity left in the heart, for the Soul had forsaken Paradise, and taken the Earth into its possession. Its mind was wholly bent upon cunning knowledge, subtility, and getting together a multitude of earthly things. No righteousness nor virtue remained in it at all; but whatsoever evil and wrong it committed, it covered all cunningly under the cloak of its power and authority by law, and called it by the name of Right and Justice, and accounted it good.

The Devil came to the Soul

Upon this the Devil drew near the Soul, and brought it on from one vice to another, for he had taken it captive in his Essence, and set joy and pleasure before it, therein, saying thus to it: Behold now thou art powerful, mighty, and noble, endeavour to be greater, richer, and more powerful still. Display thy knowledge, wit and subtlety, that every one may fear thee, and stand in awe of thee,

114

and that thou mayst be respected, and get a great name in the World.

The Soul did so

The Soul did as the Devil counselled it, and yet knew not that its counsellor was the Devil; but thought it was guided by its own knowledge, wit, and understanding, and that it did very well and right all the while.

Jesus Christ met with the Soul

The Soul going on in this course of life, our dear and loving Lord Jesus Christ, Who was come into this World with the Love and Wrath of God, to destroy the works of the Devil, and to execute judgment upon all ungodly deeds, on a time met with it, and spake by a strong power, viz., by his passion and death into it, and destroyed the works of the Devil in it, and discovered to it the way to his Grace, and shone upon it with his mercy, calling it to return and repent, and promising that he would then deliver it from that monstrous deformed shape and image which it had gotten, and bring it into Paradise again.

How Christ brought in the Soul

Now when the Spark of the Love of God, or the Divine Light, was accordingly manifested in the Soul, it presently saw itself with its will and works to be in Hell, in the Wrath of God, and found it was an ugly, misshapen monster in the Divine Presence and the Kingdom of Heaven: at which it was so affrighted, that it fell into

the greatest anguish possible, for the Judgment of God was manifested in it.

What Christ said

Upon this the Lord Christ spake unto it with the Voice of his Grace, and said: Repent and forsake Vanity, and thou shalt attain My Grace.

What the Soul said

Then the Soul with its ugly misshapen image went before God and entreated for Grace and the pardon of its sins, and came to be strongly persuaded in itself that the satisfaction and atonement of our Lord Jesus Christ did belong to it. But the evil properties of the Serpent, formed in the Astral Spirit, or Reason, of the outward Man, would not suffer the Will of the Soul to come before God, but brought their lusts and inclinations thereinto.

But the poor Soul turned its countenance towards God, and desired Grace from him, even that he would bestow his Love upon it.

The Devil came to it again

But when the Devil saw that the Soul thus prayed to God, and would enter into repentance, he drew near to it, and thrust the inclinations of the earthly properties into its prayers, and disturbed its good thoughts and desires which pressed forwards towards God, and drew them back again to earthly things that they might have no access to him.

116

The central Will of the Soul indeed sighed after God, but the thoughts arising in the mind that it should penetrate into him, were distracted, scattered and destroyed, so that they could not reach the Power of God. At which the poor Soul was still more affrighted and began to pray more earnestly. But the Devil with his desire took hold of the kindled, fiery Wheel of Life, and awakened the evil properties, so that evil or false inclinations arose in the Soul, and went into that thing wherein they had taken most pleasure and delight before.

The poor Soul would very fain go forward to God with its Will, and therefore used all its endeavours; but its thoughts continually fled away from God into earthly things, and would not go to him.

Upon this the Soul sighed and bewailed itself to God; but was as if it were quite forsaken by him, and cast out from its Presence. It could not get so much as one look of Grace, but was in mere anguish, fear and terror, and dreaded every moment that the Wrath and severe Judgment of God would be manifested in it, and that the Devil would take hold of it and have it. And thereupon fell into such great heaviness and sorrow, that it became weary of all the temporal things, which were before its chief joy and happiness.

The earthly natural Will indeed desired those things still, but the Soul would willingly leave them altogether, and desired to die to all temporal lust and joy whatsoever, and longed only after its first native country, from whence it originally came. But it found itself to be far from thence in great distress and want, and knew not what to do, yet resolved to enter into itself, and try to pray more earnestly.

But the Devil opposed it, and withheld it so that it could not bring itself into any greater fervency of repentance.

He awakened the earthly lusts in its heart, that they might still keep their evil nature and false right therein, and set them at variance with the new-born Will and Desire of the Soul. For they would not die to their own Will and Light, but would still maintain their temporal pleasures, and so kept the poor Soul captive in their evil desires, that it could not stir, though it sighed and longed never so much after the Grace of God. For whensoever it prayed, or offered to press forward towards God, then the lusts of the flesh swallowed up the rays and ejaculations that went forth from it, and brought them away from God into earthly thoughts, that it might not partake of Divine Strength. Which caused the poor Soul to think itself forsaken of God, not knowing that he was so near it, and did thus attract it. Also the Devil tempted the poor Soul, saying to it in the earthly thoughts:

"Why dost thou pray? Dost thou think that God knoweth thee or regardeth thee? Consider but what thoughts thou hast in his presence; are they not altogether evil? Thou hast no faith or belief in God at all; how then should he hear thee? He heareth thee not, leave off; why wilt thou needlessly torment and vex thyself! Thou hast time enough to repent at leisure. Wilt thou be mad? Do but look upon the world I pray thee a little; doth it not live in jollity and mirth, yet it will be saved well enough for all that. Hath not Christ paid the ransom and satisfied for all men? Thou needest only persuade and comfort thyself that it is done for thee, and then thou shalt be saved. Thou canst not possibly in this world come to any

118

feeling of God, therefore leave off, and take care for thy body, and look after temporal glory. What dost thou suppose will become of thee, if thou turn to be so stupid and melancholy? Thou wilt be the scorn of everybody, and they will laugh at thy folly; and so thou wilt pass thy days in mere sorrow and heaviness, which is pleasing neither to God nor Nature. I pray thee, look upon the beauty of the World, for God hath so erected and placed thee in it, to be a Lord over all Creatures and to rule them. Gather store of temporal goods beforehand, that thou mayest not be beholden to the World, or stand in need hereafter. And when old age cometh, or that thou growest near thy end, then prepare thyself for repentance. God will save thee, and receive thee into the heavenly mansions there. There is no need of such ado in vexing, bewailing, and stirring up thyself, as thou makest."

The Condition of the Soul

In these and the like thoughts the Soul was ensnared by the Devil, and brought into the lust of the flesh, and earthly desires; and so bound as it were with fetters and strong chains that it did not know what to do. It looked back a little into the World and the pleasures thereof, but still felt in itself a hunger after Divine Grace, and would rather enter into repentance and favour with God. For the Hand of God had touched and bruised it, and therefore it could rest nowhere; but always sighed in itself after sorrow for the sins it had committed, and would fain be rid of them. Yet could not get true repentance, or even the knowledge of sin, though it had a mighty hunger and longing desire after such penitential sorrow.

The Soul being thus heavy and sad, and finding no remedy or rest, began to cast about where it might find a fit place to perform true

repentance in, where it might be free from business, cares, and the hinderances of the World; and also by what means it might win the favour of God. And at length purposed to betake itself to some private solitary place, and give over all worldly employments and temporal things, and hoped that by being bountiful and pitiful to the Poor, it should obtain God's mercy. Thus did it devise all kinds of ways to get rest, and to gain the love, favour, and grace of God again. But all would not do; for its worldly business still followed it in the lusts of the flesh, and it was ensnared in the net of the Devil now, as well as before, and could not attain rest. And though for a little while it was somewhat cheered with earthly things, yet presently it fell to be as sad and heavy again as it was before. The truth was it felt the awakened Wrath of God in itself, but knew not how that came to pass, nor what ailed it. For many times great trouble and terror fell upon it, which made it comfortless, sick, and faint with very fear; so mightily did the first bruising it with the ray or influence of the stirring of Grace work upon it. And yet it knew not that Christ was in the Wrath and severe Justice of God and fought therein with that Spirit of Error incorporated in Soul and Body, nor understood that the hunger and desire to turn and repent came from Christ Himself, neither did it know what hindered it that it could not yet attain to Divine Feeling. It knew not that itself was a monster, and did bear the Image of the Serpent.

An enlightened and regenerate Soul met the distressed Soul

By the Providence of God, an enlightened and regenerate Soul met the distressed Soul, and said: What ailest thou, thou distressed Soul, that thou art so restless and troubled!

The distressed Soul answered

The Creator hath hid his Countenance from me, so that I cannot come to his Rest; therefore I am thus troubled, and know not what I shall do to get his Loving-kindness again. For great cliffs and rocks lie in my way to his Grace, so that I cannot come to him. Though I sigh and long after him never so much, yet I am kept back, so that I cannot partake of his Power, Virtue, and Strength.

The enlightened Soul said

Thou bearest the monstrous shape of the Devil, and art clothed therewith; in which, being his own Property or Principle, he hath access or power of entrance into thee, and thereby keepeth thy Will from penetrating into God. For if thy Will might penetrate into God, it would be anointed with the highest Power and Strength of God, in the Resurrection of our Lord Jesus Christ; and that unction would break in pieces the monster which thou carriest about thee; and thy first Image of Paradise would revive in the Centre; which would destroy the Devil's Power therein, and thou wouldst become an Angel again. And because the Devil envieth thee this happiness, he holdeth thee captive in his Desire in the lusts of the flesh, from which if thou art not delivered, thou wilt be separated from God, and canst never enter into our Society.

The distressed Soul terrified

At this speech the poor distressed Soul was so terrified and amazed, that it could not speak one word more. When it found that it stood in the form and condition of the Serpent which separated it from God, and that the Devil was so nigh it in that condition, who

121

injected evil thoughts into the Will of the Soul, and had so much power over it thereby that it was near damnation and sticking fast in the Abyss or bottomless pit of Hell in the Anger of God, it would have even despaired of Divine Mercy; but that the Power, Virtue and Strength of the first stirring of the Grace of God, which had before bruised the Soul, upheld and preserved it from total despair. But still it wrestled in itself between Hope and Doubt; whatsoever Hope built up, that Doubt threw down again. And thus was it agitated with such continued disquiet, that at last the World and all the glory thereof became loathsome to it, neither would it enjoy worldly pleasures any more; and yet for all this could it not come to Rest.

The enlightened Soul came again, and spoke to the troubled Soul

On a time the enlightened Soul came again to this Soul, and finding it still in so great trouble, anguish, and grief, said to it.

What dost thou? Wilt thou destroy thyself in thy anguish and sorrow? Why dost thou torment thyself in thy own Power and Will, seeing thy torment increaseth thereby more and more? Yea, if thou shouldst sink thyself down to the bottom of the sea, or fly to the uttermost coasts of the morning, or raise thyself above the stars, yet thou wouldst not be released. For the more thou grievest, tormentest, and troublest thyself, the more painful thy nature will be; and yet thou wilt not be able to come to Rest. For thy Power is quite lost, and as a dry stick burnt to a coal cannot grow green and spring afresh by its own power, nor get sap to flourish again with other trees and plants; so neither canst thou reach the Place of God by thy own power and strength, and transform thyself into that Angelical Image which thou hadst at first. For in respect to God

122

thou art withered and dry, like a dead plant that hath lost its sap and strength, and so art become a dry tormenting Hunger. Thy Properties are like Heat and Cold which continually strive one against the other, and can never unite.

The distressed Soul said

What then shall I do to bud forth again, and recover the first Life, wherein I was at rest before I became an Image?

The enlightened Soul said

Thou shalt do nothing at all but forsake thy own Will, viz., that which thou callest I, or thyself. By which means all thy evil properties will grow weak, faint, and ready to die; and then thou wilt sink down again into that One Thing from which thou art originally sprung. For now thou liest captive in the Creatures; but if thy Will forsaketh them, they will die in thee, with their evil inclinations, which at present stay and hinder thee that thou canst not come to God. But if thou takest this course, thy God will meet thee with his infinite Love, which he hath manifested in Christ Jesus in the Humanity, or human Nature. And that will impart sap, life and vigour to thee, whereby thou mayst bud, spring, flourish again, and rejoice in the Living God, as a branch growing on his true Vine. And so thou wilt at length recover the Image of God, and be delivered from that of the Serpent. Then shalt thou come to be my brother and have fellowship with the Angels.

The poor Soul said

How can I forsake my Will, so that the Creatures which lodge

therein may die, seeing I must be in the World, and also have need of it as long as I live?

The enlightened Soul said

Now thou hast worldly power and riches, which thou possesses! as thy own, to do what thou wilt with, and regardest not how thou gettest or invest the same, employing them in the service or indulgence of thy carnal and vain desires. Nay though thou seest the poor and needy wretch who wanteth thy help, and is thy brother, yet thou helpest him not, but layest heavy burdens upon him, by requiring more of him than his abilities will bear, or his necessities afford, and oppressest him, by forcing him to spend his labour and sweat for thee and the gratification of thy voluptuous Will. Thou art moreover proud and exultest over him, and behavest roughly and sternly to him, exalting thyself above him, and making small account of him in respect of thyself. Then that poor oppressed brother of thine cometh, and complaineth with sighs towards God, that he cannot reap the benefit of his labours and pains, but is forced by thee to live in misery. By which sighings and groanings of his he raiseth up the wrath of God in thee, which maketh thy flame and unquietness still the greater.

These are the Creatures which thou art in love with, and hast broken thyself off from God for their sakes, and brought thy Love into them or them into thy Love, so that they live therein. Thou nourishest and keepest them by continually receiving them into thy desire, for they live in and by thy receiving them into thy mind, because thou thereby bringest the lust of thy Life into them. They are but unclean and evil births and issues of the Bestial Nature, which yet by thy receiving them in thy Desire, have gotten an

124

Image and formed themselves in thee. And that Image is a beast with four heads. First, Pride. Secondly, Covetousness. Thirdly, Envy. Fourthly, Anger. And in these four properties the Foundation of Hell consisteth, which thou earnest in thee and about thee. It is imprinted and engraven in thee, and thou art wholly taken captive thereby. For these properties live in thy Natural Life; and thereby thou art severed from God, neither canst thou ever come to him, unless thou so forsake these evil Creatures that they may die in thee.

But since thou desirest me to tell thee how to forsake thy own, perverse creaturely Will, that the Creatures might die, and that yet thou mightest live with them in the World, I must assure thee that there is but one way to do it, which is narrow and straight, and will be very hard and irksome to thee in the beginning, but afterwards thou wilt walk in it cheerfully.

Thou must seriously consider that in the course of this worldly life thou walkest in the Anger of God and in the Foundation of Hell; and that this is not thy true native country; but that a Christian should and must live in Christ, and in his walking truly follow him; and that he cannot be a Christian unless the Spirit and Power of Christ so live in him that he becometh wholly subject to it. Now seeing the Kingdom of Christ is not of the world, but in Heaven, therefore thou must be always in a continual ascension towards Heaven, if thou wilt follow Christ; though thy body must dwell among the Creatures and use them.

The narrow way to which perpetual ascension into Heaven and imitation of Christ is this. Thou must despair of all thy own power and strength, for in and by thy own thou canst not reach the Gates

of God, and firmly purpose and resolve wholly to give thyself up to the Mercy of God, and to sink down with thy whole mind and reason into the Passion and Death of our Lord Jesus Christ, always desiring to persevere in the same and to die from all thy Creatures therein. Also thou must resolve to watch and guard thy mind, thoughts, and inclinations that they admit no evil into them, neither must thou suffer thyself to be held fast by temporal honour or profit. Thou must resolve likewise to put away from thee all Unrighteousness and whatsoever else may hinder the freedom of thy motion and progress. Thy Will must be wholly pure and fixed in a firm resolution never to return to its old idols any more, but that thou wilt, that very instant leave them, and separate thy mind from them, and enter into the sincere way of truth and righteousness, according to the plain and full doctrine of Christ. And as thou dost thus purpose to forsake the enemies of thine own inward Nature, so thou must also forgive all thy outward enemies and resolve to meet them with thy Love, that there may be left no Creature, Person, or Thing at all able to take hold of thy Will and captivate it; but that it may be sincere and purged from all Creatures. Nay, further, if it should be required, thou must be willing and ready to forsake all thy temporal honour and profit for Christ's sake, and regard nothing that is earthly so as to set thy heart and affections upon it; but esteem thyself in whatsoever state, degree and condition thou art, as to worldly rank and riches, to be but a servant of God, and of thy fellow-Christians; or as a steward in the office wherein thy Lord hath placed thee. All arrogance and self-exaltation must be humbled, brought low, and so annihilated that nothing of thine own or of any other Creature may stay in thy Will to bring the thoughts or imagination to be set upon it.

Thou must also firmly impress it on thy mind that thou shalt

certainly partake of the promised Grace in the Merit of Jesus Christ, viz., of his outflowing Love, which indeed is already in thee, and which will deliver thee from thy Creatures, and enlighten thy Will, and kindle it with the Flame of Love, whereby thou shalt have victory over the Devil. Not as if thou couldst will or do anything in thy own strength, but only enter into the suffering and resurrection of Jesus Christ, and take them to thyself, and with them assault and break in pieces the kingdom of the Devil in thee. Thou must resolve to enter into this way this very hour, and never to depart from it, but willingly to submit thyself to God in all thy endeavours and doings, that he may do with thee what he pleaseth.

When thy Will is thus prepared and resolved, it hath then broken through its own Creatures, and is sincere in the Presence of God, and clothed with the Merits of Jesus Christ. It may then freely go to the Father with the Prodigal Son, and fall down in his Presence and pour forth its prayers; and putting forth all its strength in this Divine Work, confess its sins and disobedience; and how far it hath departed from God. This must be done not with bare words, but with all its strength, which indeed amounteth only to a strong purpose and resolution; for the Soul of itself hath no strength or power to effect any good work.

Now when thou art thus ready, and thy heavenly Father shall see thee coming and returning to him in such repentance and humility, he will inwardly speak to thee, and say in thee; Behold, this is my son which I had lost, he was dead and is alive again. And he will come to meet thee in thy mind with the Grace and Love of Jesus Christ, and embrace thee with the beams of his Love, and kiss thee with his Spirit and Strength, and then thou shalt receive Grace to pour out thy confession before him and to pray powerfully. This

indeed is the right place where thou must wrestle in the Light of his Countenance. And if thou standest resolutely here and shrinkest not back, thou shalt see or feel great wonders. For thou shalt find Christ in thee assaulting Hell, and crushing thy Beasts in pieces, and that a great tumult and misery will arise in thee; also thy secret undiscovered sins will then first awake and labour to separate thee from God, and to keep thee back. Thus shalt thou truly find and feel how Death and Life fight one against the other, and shalt understand by what passeth within thyself what Heaven and Hell are. At all which be not moved, but stand firm and shrink not; for at length all thy Creatures will grow faint, weak, and ready to die; and then thy Will shall wax stronger, and be able to subdue and keep down the evil inclinations. So shall thy Will and Mind ascend into Heaven every day, and thy Creatures gradually die away. Thou wilt get a Mind wholly new, and begin to be a new Creature, and, getting rid of the Bestial Deformity, recover the Divine Image. Thus shalt thou be delivered from thy present Anguish, and return to thy original Rest.

The poor Soul's Practice

Then the poor Soul began to practise this course with so much earnestness that it conceived it should get the victory presently, but it found that the Gates of Heaven were shut against it in its own strength and power, and it was, as it were, rejected and forsaken by God, and received not so much as one look or glimpse of Grace from him. Upon which it said to itself; Surely thou hast not sincerely submitted thyself to God. Desire nothing at all of him, but only submit thyself to his judgment and condemnation, that he may kill thy evil inclinations. Sink down into him beyond the Limits of Nature and Creature, and submit thyself to him, that he may do with thee what he will, for thou art not worthy to speak to him.

Accordingly the Soul took a resolution to sink down, and to forsake its own will; and when it had done so there fell upon it presently the greatest repentance that could be for the sins it had committed; and it bewailed bitterly its ugly shape, and was truly and deeply sorry that the evil Creatures did dwell in it. And because of its sorrow it could not speak one word more in the Presence of God, but in this repentance did consider the bitter Passion and Death of Jesus Christ, viz., what great anguish and torment he had suffered for its sake, in order to deliver it out of its anguish, and change it into the Image of God. In which consideration it wholly sank down, and did nothing but complain of its ignorance and negligence, and that it had not been thankful to its Redeemer, nor once considered the great love he had shown to it, but had idly spent its time, and not at all regarded how it might come to partake of his purchased and proffered Grace; but instead thereof had formed in itself the images and figures of earthly things, with the vain lusts and pleasures of the World. Whereby it had gotten such bestial inclinations that now it must lie captive in great misery, and for very shame dared not lift up its eyes to God, Who hid the light of his countenance from it and would not so much as look upon it. And as it was thus sighing and crying it was drawn into the Abyss or Pit of Horror, and laid as it were at the Gates of Hell there to perish. Upon which the poor troubled Soul was, as it were, bereft of sense, and wholly forsaken, so that it in a manner forgot all its doings, and would willingly yield itself to Death, and cease to be a Creature. Accordingly it did yield itself to Death, and desired nothing else but to die and perish in the Death of its Redeemer Jesus Christ, who had suffered such torments and death for its sake. And in this perishing it began to sigh and pray in itself very inwardly to the Divine Goodness, and to sink down into the mere Mercy of God.

129

Upon this there suddenly appeared unto it the Love of God, as a great Light which penetrated through it, and made it exceedingly joyful. It then began to pray aright, and to thank the Most High for such Grace, and to rejoice abundantly that it was delivered from the Death and Anguish of Hell. Now it tasted of the Sweetness of God, and of his promised Truth; and how all the evil Spirits which had harassed it before, and kept it back from the Grace, Love, and inward Presence of God, were forced to depart from it. The wedding of the Lamb was now kept and solemnised, that is, the Noble Sophia espoused or betrothed herself to the Soul, and the Seal-Ring of Christ's victory was impressed into its Essence, and it was received to be a Child and Heir of God again.

When this was done the Soul became very joyful, and began to work in this new power, and to celebrate with praise the wonders of God, and thought thenceforth to walk continually in the same Light, Strength, and Joy. But it was soon assaulted: from without by the shame and reproach of the World, and from within by great temptation, so that it began to doubt whether its ground was truly from God, and whether it had really partaken of his Grace. For the accuser Satan went to it, and would fain lead it out of its course, and make it doubtful whether it was the true way, whispering thus to it inwardly; This happy change in thy Spirit is not from God, but only from thy own imagination. Also the Divine Light retired in the Soul, and shone but in the inward ground, as fire raked up in embers, so that Reason was perplexed, and thought itself forsaken, and the Soul knew not what had happened to itself, nor whether it had really and truly tasted of the heavenly gift or not. Yet it could not leave off struggling; for the burning Fire of Love was sown in it, which had raised in it a vehement and continual Hunger and Thirst after the Divine Sweetness. So at length it began to pray aright, and

to humble itself in the Presence of God, and to examine and try its evil inclinations and thoughts, and to put them away. By which means the Will of Reason was broken, and the evil inclinations inherent in it were killed and extirpated more and more. This process was very severe and painful to the Nature of the Body, for it made it faint and weak as if it had been very sick; and yet it was no natural sickness that it had, but only the melancholy of its earthly Nature, feeling and lamenting the destruction of its evil lusts.

Now when the earthly Reason found itself thus forsaken, and the poor Soul saw that it was despised outwardly and derided by the World, because it would walk no longer in the way of Wickedness and Vanity; and also that it was inwardly assaulted by the accuser Satan, who mocked it, and continually set before it the beauty, riches and glory of the World, and called it a fool for not embracing them; it began to think and say thus within itself: O eternal God, what shall I now do to come to Rest?

The enlightened Soul met it again and spoke to it

While it was in this consideration, the enlightened Soul met with it again, and said: What ailest thou, my Brother, that thou art so heavy and sad!

The distressed Soul said

I have followed thy counsel, and thereby attained a ray or emanation of the Divine Sweetness, but it is gone from me again, and I am now deserted. Moreover I have outwardly very great trials and afflictions in the World, for all my good friends forsake

and scorn me; and am also inwardly assaulted with anguish and doubt, and know not what to do.

The enlightened Soul said

Now I like thee very well; for now our beloved Lord Jesus Christ is performing that Pilgrimage or Process on Earth with thee and in thee, which he did himself when he was in this World, who was continually reviled, despised, and evil spoken of, and had nothing of his own in it; and now thou bearest his mark or badge. But do not wonder at it, or think it strange; for it must be so, in order that thou mayst be tried, refined, and purified. In this Anguish and Distress thou wilt necessarily hunger and cry after deliverance; and by such Hunger and Prayer thou wilt attract Grace to thee both from within and from without. For thou must grow from above and from beneath to be the Image of God again. Just as a young plant is agitated by the wind, and must stand its ground in heat and cold, drawing strength and virtue to it from above and from beneath by that agitation, and must endure many a tempest, and undergo much danger before it can come to be a tree and bring forth much fruit. For through that agitation the virtue of the sun moveth in the plant, whereby its wild properties come to be penetrated and tinctured with the solar virtue, and grow thereby.

And this is the time wherein thou must play the part of a valiant soldier in the Spirit of Christ, and co-operate thyself therewith. For now the Eternal Father by his fiery Power begetteth his Son in thee, who changeth the Fire of the Father, namely, the first Principle, or Wrathful Property of the Soul, into the Flame of Love, so that out of Fire and Light (viz. Wrath and Love) there cometh to be one Essence, Being, or Substance, which is the true Temple of God. And

now thou shalt bud forth out of the Vine Christ, in the Vineyard of God, and bring forth fruit in thy life, and by assisting and instructing others, show forth thy Love in abundance, as a good tree. For Paradise must then spring up again in thee, through the Wrath of God, and Hell be changed into Heaven in thee. Therefore be not dismayed at the temptations of the Devil, who seeketh and striveth for the Kingdom which he once had in thee, but, having now lost it, must be confounded, and depart from thee. And he covereth thee outwardly with the shame and reproach of the World, that his own shame may not be known, and that thou mayst be hidden to the World. For with thy New Birth or regenerated Nature thou art in the Divine Harmony in Heaven. Be patient, therefore, and wait upon the Lord, and whatsoever shall befall thee, take it all from his hands as intended by him for thy highest good. And so the enlightened Soul departed from it.

The distressed Soul's course

The distressed Soul began its course now under the patient Suffering of Christ, and depending solely upon the Strength and Power of God in it, entered into Hope. Thenceforth it grew stronger every day, and its evil inclinations died more and more in it. So that it arrived at length to a high state or degree of Grace; and the Gates of the Divine Revelation and the Kingdom of Heaven were opened to and manifested in it.

And thus the Soul, through Repentance, Faith, and Prayer, returned to its true Rest, and became a right and beloved Child of God again; to which may He of his infinite Mercy help us all. Amen.

9 798888 304174